IF YOU'RE BORED WITH YOUR CAMERA READ THIS BOOK

An Hachette UK Company
www.hachette.co.uk

First published in Great Britain in 2017 by ILEX,
a division of Octopus Publishing Group Ltd
Carmelite House
50 Victoria Embankment
London EC4Y 0DZ
www.octopusbooks.co.uk

Distributed in the US by
Hachette Book Group
1290 Avenue of the Americas
4th and 5th Floors
New York, NY 10104

Distributed in Canada by
Canadian Manda Group
664 Annette St.
Toronto, Ontario, Canada M6S 2C8

Publisher: Roly Allen
Publisher, Photo: Adam Juniper
Editor: Francesca Leung
Managing Specialist Editor: Frank Gallaugher
Project Editor: Haley Steinhardt
Admin Assistant: Sarah Vaughan
Art Director: Julie Weir
Designer: Louise Evans
Production Controller: Meskerem Berhane

ISBN 978-1-78157-431-7

A CIP catalogue record for this book is available from the
British Library.

Printed and bound in China

10 9 8 7 6 5 4 3 2 1

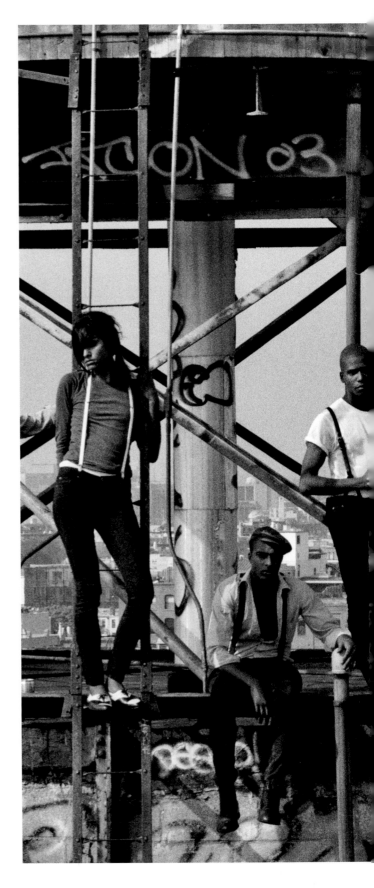

IF YOU'RE BORED WITH YOUR CAMERA READ THIS BOOK

DEMETRIUS FORDHAM

ilex

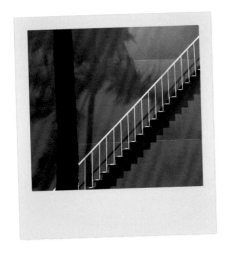

CONTENTS

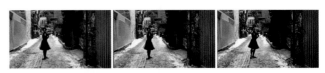
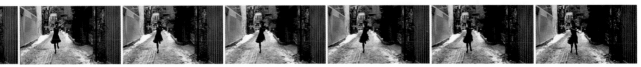

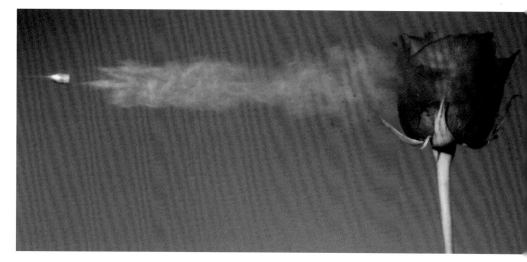

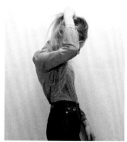

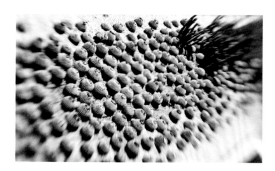

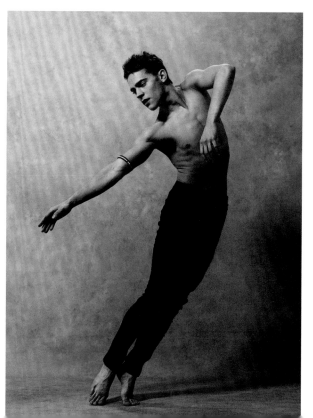

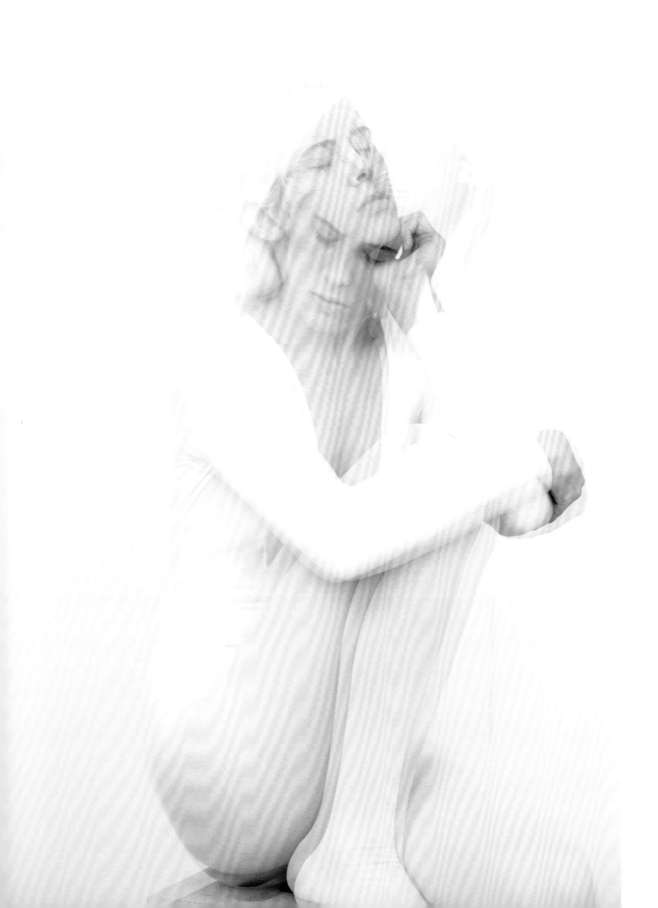

INTRODUCTION

Stuck in a rut? Keep taking the same old boring pictures again and again? In need of some serious inspiration? Trust me, I get it. I've been doing this for over ten years professionally and I most certainly get it. I'm completely with you. Photography may be my life's work and passion, but between you and me, I get bored with my camera, too.

Don't worry; it's totally normal. You see, picking up a camera and taking a picture is just the beginning. Capturing meaningful images, telling compelling visual stories, continuing to evolve as a photographer, and staying motivated and inspired throughout the entire process—now that's the tough part.

Sometimes, we all need a little help getting those creative juices flowing again.

The truth is, no photographer is blessed with a bottomless well of inspiration that can be dipped into on demand. Innovation and creativity don't always come naturally. Sometimes, we all need a little help getting those creative juices flowing again. That's why I wrote this book.

Within these pages, you'll find 50 tried-and-true tips and tricks for boosting creativity. From turning traditional photography rules on their head (Rule of Thirds what?) to fun shooting exercises and challenges, I'm confident that you'll find enough inspiration in here to get you excited about your camera again.

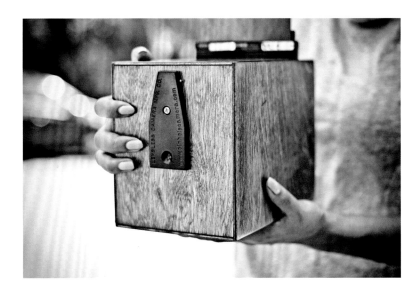

PUT DOWN YOUR CAMERA

You've heard the phrase, "absence makes the heart grow fonder" when it comes to relationships. Well, the same thing goes for your relationship with your camera. Uninspired? Stuck in a rut? Don't force it. Take a break. Put the camera down.

As with relationships, a little distance might be just what you need to clear the static from your head and remember why you started taking pictures in the first place. In this section, you'll find some tips that'll help you fall out of boredom—and maybe even back in love—with your camera.

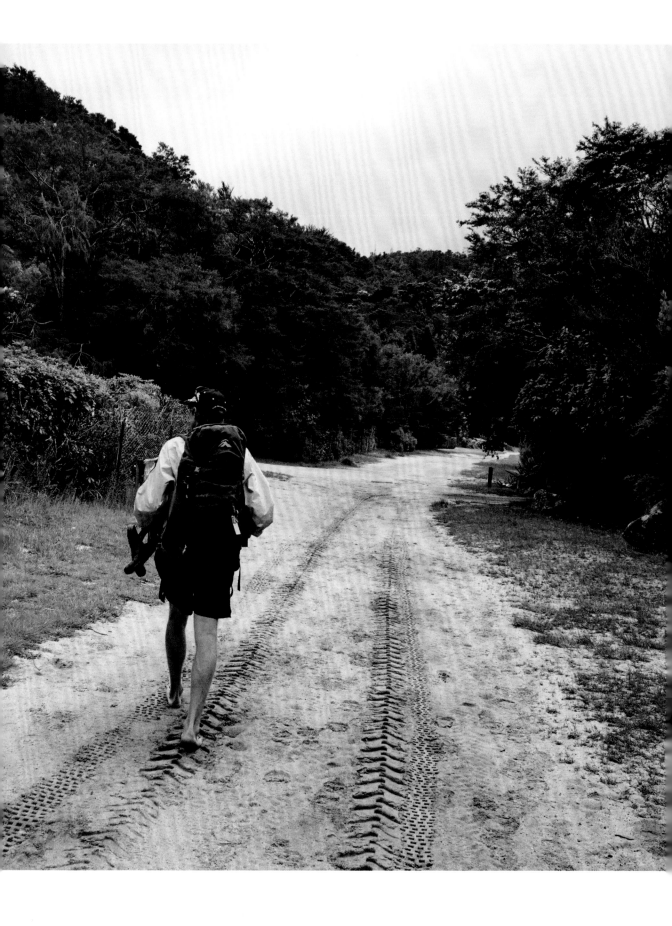

CREATE AN INSPIRATION BOARD

One of the easiest and most powerful ways to boost creativity when you're bored with your camera is to put together an inspiration board that reminds you why you want to take pictures in the first place.

The simple act of putting together a board filled with images that inspire you (I even add quotes, song lyrics, and color swatches) not only helps to get those creative juices flowing in the moment, but it also serves as a great reference for when you're feeling unmotivated in the future—which happens to even the most seasoned pros.

You can put a board together for a specific reason—for example, one based on a specific location you want to photograph—or just create a general board filled with random images that you're drawn to. I personally have separate boards for specific categories or genres of photography—like portraiture, nature, and black-and-white photos—and I'm continually adding images that inspire me to each of them. I source most of my images from magazines, but if I see something online that speaks to me, I'll print it out and add it to the board.

* **TIP: If you can't be bothered (or don't have the wall space) to create a physical inspiration board, you can easily create a digital board. There are plenty of online board-creating tools like Pinterest (no, it's not just for weddings and fashion bloggers!) and Moodboard that allow you to create a board while saving you the paper cuts.**

WHAT'S THE STORY?

Taking a beautiful photograph is one thing, but creating meaning behind it is something else entirely.

Before pointing and shooting, ask yourself:
– Why am I taking this picture?
– If this picture had a story, what would it be?
– How can I communicate this story visually?

Sure, you can tell a story with a series of images, but the real challenge is trying to convey a great story within one single image. One way I like to find "the story" is by looking out for the natural details in the scene before me: weird juxtapositions and small oddities, reflections, shadows, lines, and textures. Sometimes, the most powerful story is in the abbreviated version of a scene, even focusing in on one single detail rather than the scene in its entirety.

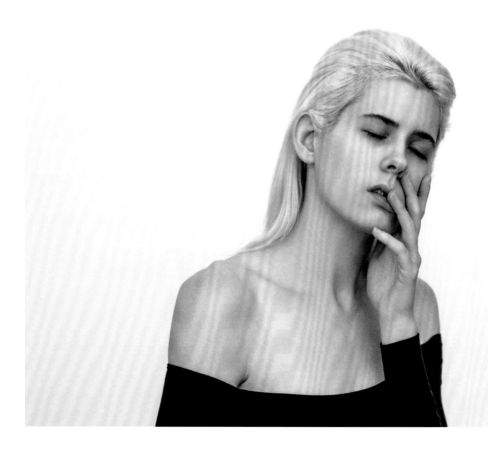

Shooting portraits? I like to carefully study a person before photographing them. The least creepy way to do this is by having a conversation. Ask them to tell their story before attempting to tell it visually in a photograph. Keep an eye out for elements of their personality that reveal themselves through physical attributes: a cheeky smile, deep laugh lines, disheveled hair, weathered hands. Consider the context—perhaps including your subject's environment might add further meaning and perspective—or try focusing in on a particular detail. The bottom line? Ask yourself, "What am I trying to say here?," and then figure out ways to say it.

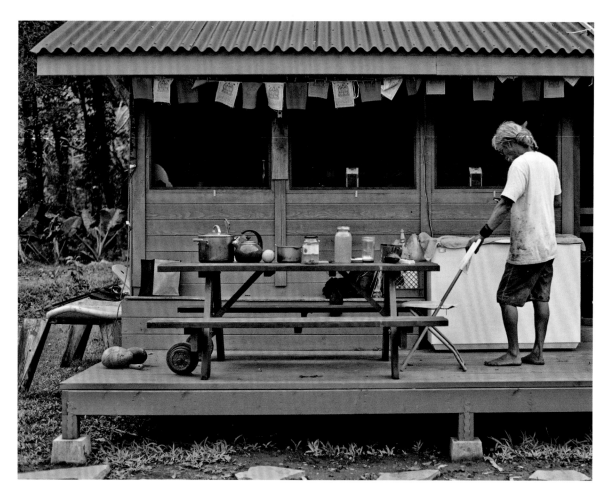

* **TIP: One of my favorite techniques to communicate a story visually is playing with angles. The angle in which a photo is taken can dramatically convey meaning. For example, shooting a subject from a low angle will tell a different story than if the subject was shot from above. The same goes for wide shots versus tight shots.**

DRAW OR PAINT SOMETHING

Put down the camera and pick up a pencil or paintbrush. Seriously. To be a good photographer, you have to learn to look at the world differently, and learning to draw or paint is a great way to change how you look at things.

Try this quick exercise: Look outside your window. Unless you live on a tropical island, your view is probably fairly mundane: other houses, parked cars, trees, maybe a lawn, and so on. Not particularly photo-worthy, right?

Now, pick up a pencil or a paintbrush and try to draw or paint the scene in front of you. Trying to recreate the scene with your own hand requires you to study every small detail in front of you: the soft, golden light reflecting off the car windows, a flower growing through a crack in the sidewalk, the fact that no two leaves on the trees are alike. The process of drawing and painting forces you to look carefully and closely at the world around you, and teaches you to see rather than just look. This will make you a better photographer.

✳ TIP: Find something you actually want to photograph, but instead of bringing your camera along, take a sketchpad and pencils or watercolors—whichever speaks to you more. Spend a few hours drawing or painting your scene or subject. Remember, you're not aiming for perfection; it's the process itself, not the end result, that's important.

GO FOR A WALK

My favorite way to spark inspiration when I'm bored with my camera is to take a walk. It sounds cliché, but I don't mean just any walk: I'm talking about a walk with a purpose—and without a camera.

A few years ago, one of my mentors gave me an assignment that helped change my photography for the better. She told me to take the same walk every day at different times of the day, sans camera. (It sounds counterintuitive but, trust me, ditching the camera changes everything.) Instead of telling me to look out for interesting things to photograph, she instructed me to simply observe how the light changed at the same location during different times of the day. She asked me to study how the scenes along the way—the characters, the objects, the activity—changed over the course of the day and over the course of one entire week.

Taking the time to do this every day over a week-long period made me fall in love with light, taught me how people interact with their environments, how to truly appreciate beauty in the everyday and mundane. It showed me the multitude of stories and perspectives in one single scene. Most importantly, it taught me how to really be present in the moment, which is probably the most important takeaway any photographic exercise has ever given me. Though being trigger happy can be a good thing (see "Shoot an Entire Roll of Film" on page 48), the point of this walk is to get lost in your surroundings—not in your viewfinder.

* **BONUS: You can stumble across cool new places to shoot. It's on these camera-free walks that I've been able to find some of my favorite shooting locations.**

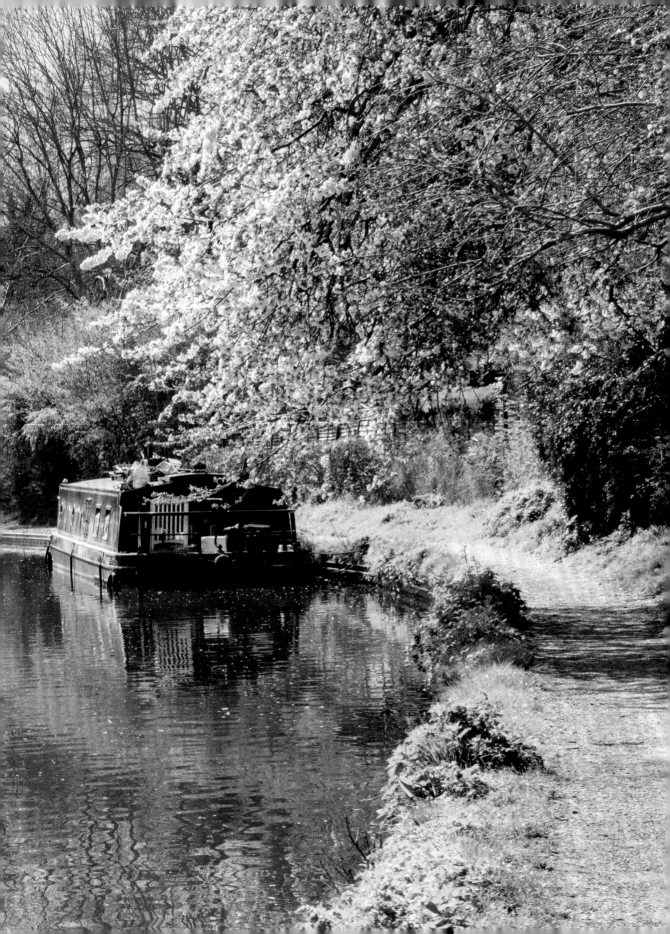

GO TO A PHOTO EXHIBIT

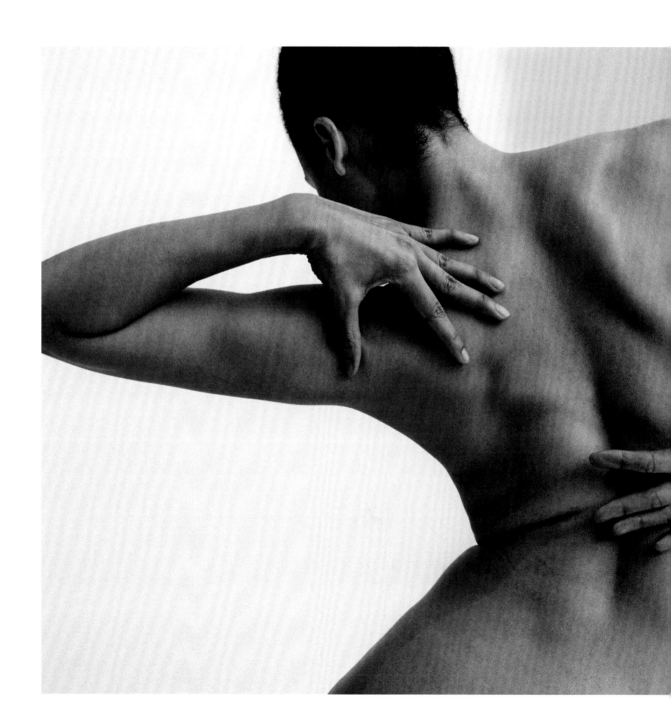

The reasons why you should attend a photo exhibit are fairly obvious, so instead of wasting precious space on that, I'd like to add this: Seek out a photo exhibit in a genre that's completely different from your own. If you like shooting landscapes, for example, go see an exhibit exclusively showcasing portraiture. The effect is like listening to different genres of music; all these various influences will open your mind, inspire you, and help inform your future work.

Sanja Iveković, for example, is a photographer whose feminist and politically charged photographs and performance art aren't even remotely similar to the photographs I take. Her exhibit at New York's Museum of Modern Art, however, inspired me to try different mediums of photography, and taught me not to be afraid to take risks and think radically outside the box.

I'd also recommend attending exhibits that showcase the work of a photographer you've never heard of. These can also be a source of fresh inspiration and give you a glimpse of what your peers are doing (and what kind of work museums are interested in if a gallery show is something you want to achieve one day).

At least once in your lifetime, try to hit at least one of the following exceptional galleries:

– International Center of Photography, New York
– Museum of Modern Art, New York
– Hamiltons Gallery, London
– Fraenkel Gallery, San Francisco
– TORCH Gallery, Amsterdam
– Galleria Carla Sozzani, Milan
– GALLERY FIFTY ONE, Antwerp
– Magnum Gallery, Paris
– CAMERA WORK, Berlin

STUDY THE MASTERS

When I need an instant jolt of inspiration, flipping through the books of iconic photographers like Henri Cartier-Bresson and Elliott Erwitt always does the trick.

Though their sheer artistry will be enough to inspire you, I'd take it a step further and study their entire bodies of work, along with other masters like Alfred Stieglitz, Ansel Adams, Nadar, Philippe Halsman, Louis Daguerre, Arnold Newman, and Yousuf Karsh (by no means an exclusive list).

Newman, for example, was one of the first photographers to practice what we now know as "environmental portraiture," and much can be learned from studying his use of lighting and masterful control of elements to tell a story. Similarly, the work of Cartier-Bresson, widely considered as the father of both street photography and photojournalism, can be examined for its tight compositions, use of natural frames, and exceptional timing. No matter what your primary genre, studying the works of master photographers can help shape and inform your own photographic style.

* **TIP:** Do a quick Google search for "master photographers" and choose three whose work speaks to you the most. Ask yourself:

– Why am I drawn to this photographer's images?
– What techniques have they used to create meaning in their images?
– What elements of their style would I like to incorporate into my own photography?

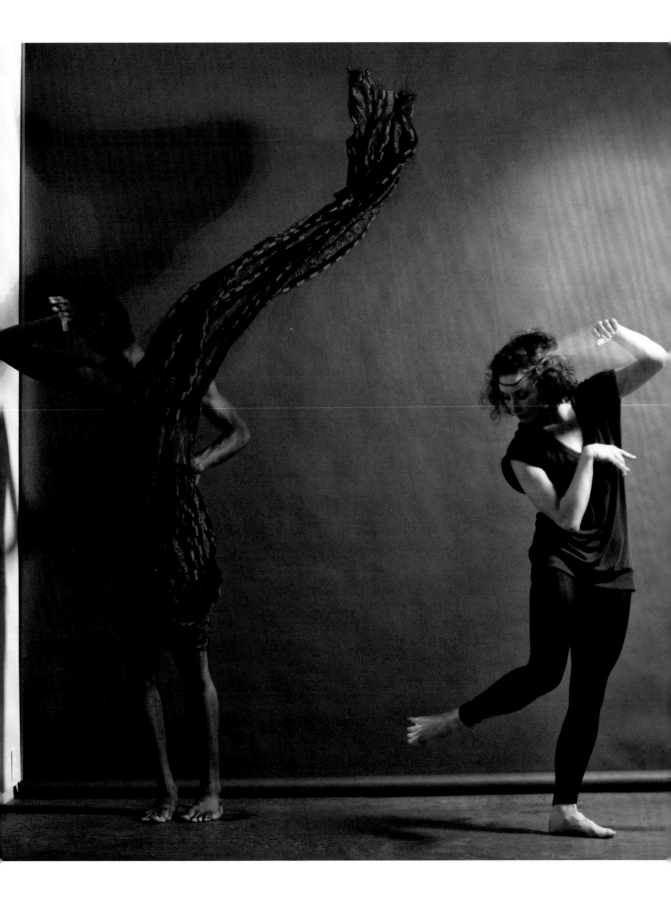

* TIP: Print out your favorite photographs from each year since you started taking pictures. Tack them up on a wall side by side, and compare them. Has your style changed? Has your technique improved over time? I find that it's so much easier to examine (and edit) a body of work when it's printed out before you.

PRINT YOUR IMAGES

In this digital age, most photographers never print their photographs, and that is a shame. Call me old school, but I swear that holding a printed photograph in my hands actually releases endorphins. Whether or not that's true, that feeling alone is enough reason to have your photographs printed, either with your own printer or in a lab.

If the sheer satisfaction is not enough, holding a tangible image in your hand will also change the way you see your own photography and help you appreciate the art form more. It probably sounds illogical, but I truly feel that I see an image better and clearer when I'm holding it in my hands as opposed to looking at it on a computer screen—even though the latter allows you to zoom in to see greater detail. There's really nothing more powerful and impactful than a beautiful, meaningful, printed photograph. (See also "Use an Instant Film Camera" on page 50.)

TRAVEL

For those who love it, there's nothing more rut-busting than traveling to a new destination. Travel is probably the single most powerful way to open your mind and transform the way you see the world and other people.

As a fellow photographer, I am most inspired when I'm traveling to someplace I've never been before. Some of the best photographs I've ever taken have been during my travels. And interestingly, just afterwards, I've found that excitement of discovery and the thrill of capturing something new and exotic often translates into the photographs that I take when I'm back home. Right after a trip, I can't help but see the world with fresh eyes, and I can see that reflected in my work.

That said, not everyone has the means—or the interest—to travel. To those people I say: Do it anyway. I don't mean drain your bank account and force yourself on an international trip; travel can mean many things and take countless forms.

Here are some ideas:

– Take a bus or train an hour outside the town where you live.
– Look at a map of your area, pick a place you've never been to at random, and go on a road trip to that place.
– Live in the city? Visit your nearest rural area or wine region.
– Live in the countryside? Visit your nearest big city or a nearby city you've never been before.
– Hop on public transportation and get off somewhere that piques your interest—just trust your gut—and explore it.

Bottom line, put yourself in completely new surroundings. Just like date night at a new spot with your longtime partner, switching up the routine and going somewhere you've never been before might help rekindle the relationship between you and your camera.

TAKE A PHOTO CLASS

Unless you're a seasoned professional photographer who's been shooting for most of your life, you'll probably want to learn some new skills and take your photography to the next level (though even pro photographers would probably argue that there's always something new to learn).

Photography classes are an excellent way for you to improve your skills among like-minded people, whether it's at a half-day workshop or a full-blown, semester-long course. If you're afraid you'll be surrounded by complete beginners, don't be. Unless it's a photography fundamentals class, I've typically found that students are a mix of amateurs and professionals, all of whom just want to kick their photography up a notch.

Most commonly, you'll attend a workshop that will address a specific skill you want to work on, like lighting or composition or even post-production, but I'd also suggest stepping outside your comfort zone and signing up for a class in a genre you've never tried before (i.e., black-and-white photography if you always shoot in color; street photography if you always shoot nature and landscapes; night photography if you only ever shoot in daylight) to challenge yourself.

✳ **TIP:** For more information on photography classes, go to your local photo institute or email your local photography organization. In the US, for example, the American Society of Media Photographers hosts regular workshops targeting everyone from top pro photographers to photo assistants, which are open to members and non-members alike.

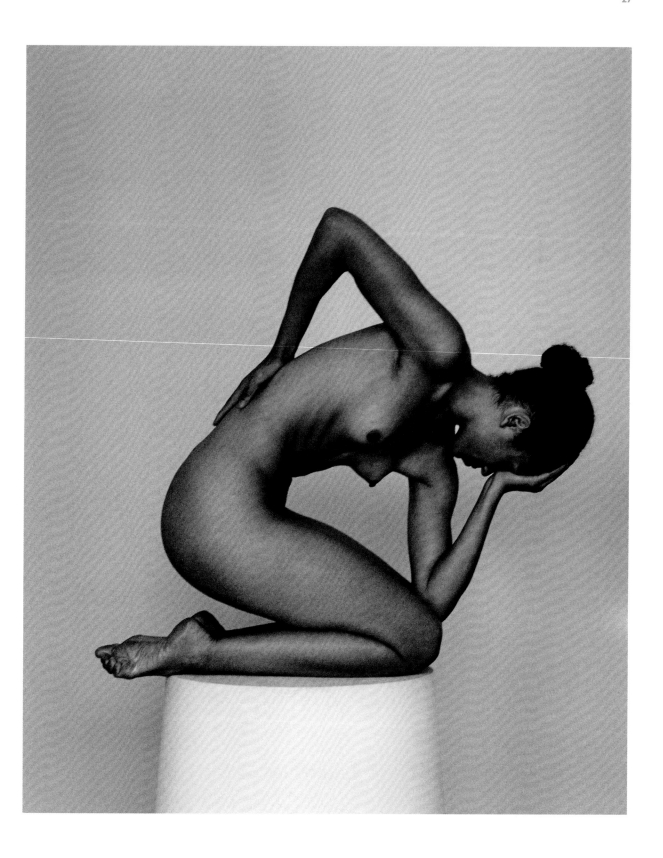

FORGET THE RULES

When it comes to photography, I'm a closet rebel. Sure, there's value in the basic rules of photographic composition and technique, but I see them more as suggestions rather than hard-and-fast directives—and I would encourage you to look at them the same way.

Of course, there's something to be said about having an expertly composed, perfectly exposed, razor-sharp, and well-lit photograph. Aiming to capture that "perfect" shot every time, however, sucks the joy and spontaneity out of taking a photo (which, quite frankly, is the whole point of doing it). In this section, we'll go through the basic rules of photography, talk about why they exist, and then flip 'em on their heads because, at the end of the day, the best pictures are the ones you take when you're having fun.

FORGET: THE RULE OF THIRDS

The Rule of Thirds—probably the best-known rule of photographic composition—states than an image is most visually pleasing when its subjects are composed along imaginary horizontal and vertical lines that divide the image into thirds.

According to this rule, the intersection points, in particular, should be where you aim to place your points of interest to achieve a perfectly composed image ... but guess what? There are many other compositional techniques that can help you create infinitely more compelling images. Ditch the Rule of Thirds and play with the following techniques instead:

⇶ CENTERING

Who says your subject or focal point can't be smack-bang in the center of your image? Many photographers steer away from a central focal point, but in certain situations— such as scenes of symmetry or portraits—I find it makes for a powerful image.

⇶ CONTINUITY AND LEADING LINES

Instead of trying to place a subject or point of interest on a Rule-of-Thirds crosshair, focus on drawing out and playing up the natural curves and lines that already exist in the scene before you. Try to locate and capture a continuous natural curve—created by people, objects, shadows, or light—running through the image.

≫→ SYMMETRY

We're surrounded by natural and man-made symmetry, which is a great thing for photographs. The mind is constantly trying to find balance and proportion in visual stimuli, which is something the Rule of Thirds does not always satisfy. (Your typical image composed using the Rule of Thirds will generally draw your eyes toward one particular section of the photograph). Next time you pick up a camera, look for the symmetry in patterns, details, and light in the scene before you and try to capture that.

✱ **TIP: Having a "break" in the symmetry in the form of one odd, inconsistent detail—like a yellow apple in a crate full of red apples—adds tension and a focal point to the image.**

⟫→ FIGURE-GROUND RELATIONSHIP

This refers to the relationship of the subject (the "figure") to the background, foreground, or landscape on which it rests (the "ground"). Play with the separation between the figure and the ground through lighting and contrast, or simply manipulate the scene by physically moving the subject in relation to its background; small tweaks can make an image that much more striking and meaningful. (Henri Cartier-Bresson was a master at capturing the figure-ground relationship.)

There are countless other compositional techniques—too many to list here—but my main suggestion is not to take composition too seriously (I know: blasphemy!). Just take as many pictures as you can and you'll find that the more you practice, the faster you'll develop an eye for what looks good.

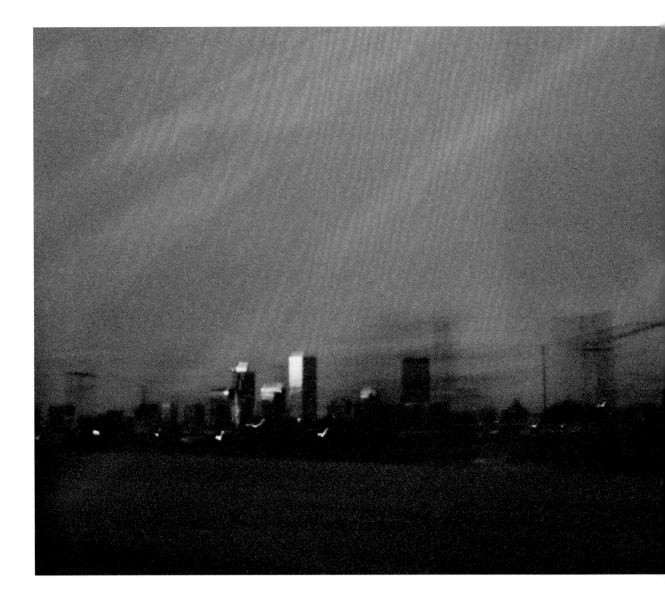

FORGET: FOCUS

Photographers are obsessed with creating tack-sharp, in-focus images for obvious reasons. There's nothing more amateurish than taking a blurry photo or having an out-of-focus subject! That said, intentional blur can create depth and dimension, and convey a specific mood or feel when done properly and on purpose. There are several ways to take a purposely unfocused image:

⋙ BLUR YOUR BACKGROUND

Making the background nice and soft by opening up your aperture and getting close to your subject—leaving only the subject in focus—can make that subject stand out dramatically from its surroundings.

⋙ BLUR YOUR SUBJECT

This is trickier because you want to make sure the effect looks clearly intentional. Usually, you'd only use this technique when capturing motion, such as when photographing a speeding train against a forest. The train would be blurred—communicating to the viewer that it is zooming by at lightning speed—while the forest in the background would remain crisp and in focus. To accomplish this, you would use a slow shutter speed and a tripod to keep the camera steady. (See also "Shoot Action" section on page 68).

⋙ TOTAL BLUR

Despite how it sounds, this doesn't mean that the entire image is one meaningless, abstract blur. It simply means that all elements of the image are purposely out of focus to create meaning. I find this works especially well with nighttime streetscapes. Always look for distinct shapes and structures that might help you to create a beautiful shape when blurred, and try not to clog the frame with too many characters or focal points (though at times, even this might create a surreal, visually intriguing effect). (See also "Use Bokeh" section on page 94).

✳ **TIP: If you really want to throw the background out of focus, getting super close to the subject is key. Even extreme wide-angle lenses can have a very shallow depth of field when the subject is inches from the lens, so really getting in there is important.**

FORGET: EXPOSURE

As with focus, photographers are taught that perfect exposure is paramount when it comes to taking good pictures. We all swear by "Sunny 16," a method for estimating exposure without a light meter that states you should set the aperture to f/16 on a bright, sunny day. (Your correct shutter speed should be the reciprocal of the ISO; in other words, 1/100 second for ISO 100, 1/400 for ISO 400, and so forth.) The aim? Perfectly exposed pictures.

Now that's all well and good, but sometimes you need to go against the grain if you want to achieve truly exciting images. Some of the most interesting photographs are far from perfectly exposed. In fact, many pro photographers purposely use a "wrong" exposure to create an effect or a specific mood. If you're bored with your camera, try these very counterintuitive techniques:

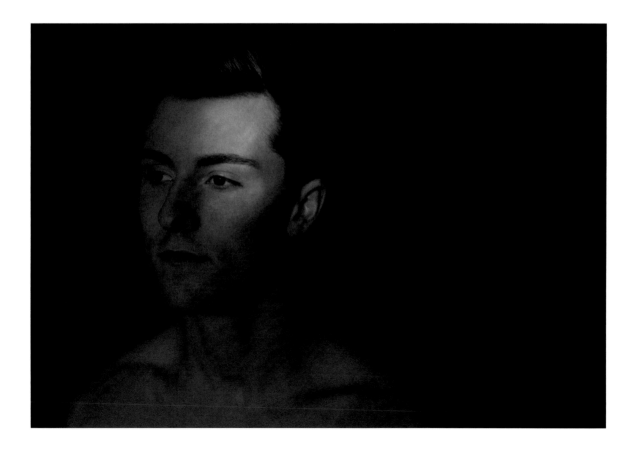

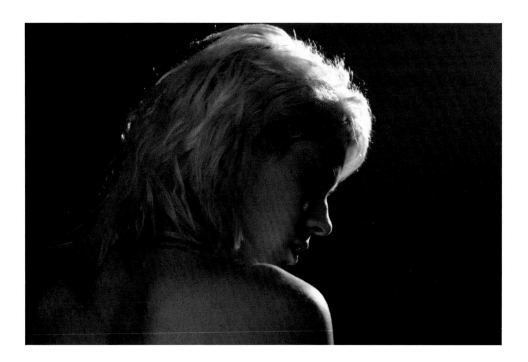

⫸ UNDEREXPOSURE

I personally love underexposing my photos. I like how shadows provide texture, mood, and drama to an image. I love the darker, more somber scenes that underexposure can achieve when shooting in dim light, and I love the silhouettes you get when the background is overwhelmingly bright. The key here is not underexposing too dramatically (by having too low an ISO setting or too fast a shutter speed), which puts you at risk of losing details and mid-tones to shadow. (You might be able to recover some of this in post-production, particularly if you're shooting Raw, but you still want to avoid it). At the end of the day though, it's all at your discretion, and if you love the way it looks, that's all that matters.

⫸ OVEREXPOSURE

Overexposing your images so that they're unnaturally bright or blown-out (by increasing the ISO or decreasing the shutter speed to let in more ambient light) is another technique that creates a specific look. Often, overexposure is effectively used to eliminate most shadows and convey or exaggerate a bright and upbeat mood; other times it is simply used for artistic effect. The results are similar to high-key photography, which means the vast majority of tones in an image are above middle gray, producing a light-drenched image with low contrast between light and dark areas. I find that a hint of overexposure (no more than 1.5–2 stops brighter) can make people look younger, make wrinkles disappear, and make your overall image look cleaner and more minimalist.

FORGET: FRAMING

Oh, the perfectly framed image! All professional photographers are trained to find that perfect frame to highlight their subject, be it natural (i.e., an overhanging tree branch, the mouth of a cave) or man-made (such as doorways, arches, or bridges). I do love an untraditional frame myself, and I'm constantly on the lookout for people and objects—or even light and shadows—that naturally frame and draw the eye toward my focal point.

Having said that, I'm also not afraid to ditch the idea of framing entirely. Though in theory it's nice to have a frame that draws attention toward your subject or focal point, I've found it totally unnecessary for the majority of the pictures I take. In many cases, I actually feel as if framing can be a crutch that takes away from the simplicity and clarity of an image. I've even seen many instances where it has simply added clutter to an otherwise sleek image, making it feel cramped and busy.

Plus, while framing is a classic compositional technique, its overuse can come across as cliché and unimaginative. (Seriously, how many times can we use a window to frame a subject?) Why not ditch the frame altogether and instead try drawing attention to your focal point through contrast, leading lines, centering, or experimenting with the figure-ground relationship (as discussed on page 33)? Blur the background (see page 35), or simply play up your focal point's colors, textures, and details.

Here's a crazy thought: Why not ditch the very idea of having a single focal point in the first place? I have always liked the idea of having two focal points—say, a big one and a smaller one—that, when executed properly, can be twice as impactful. Or you could have no focal point at all (controversial!) and create an image that's overwhelmingly abstract and entirely unique. Take that, framing!

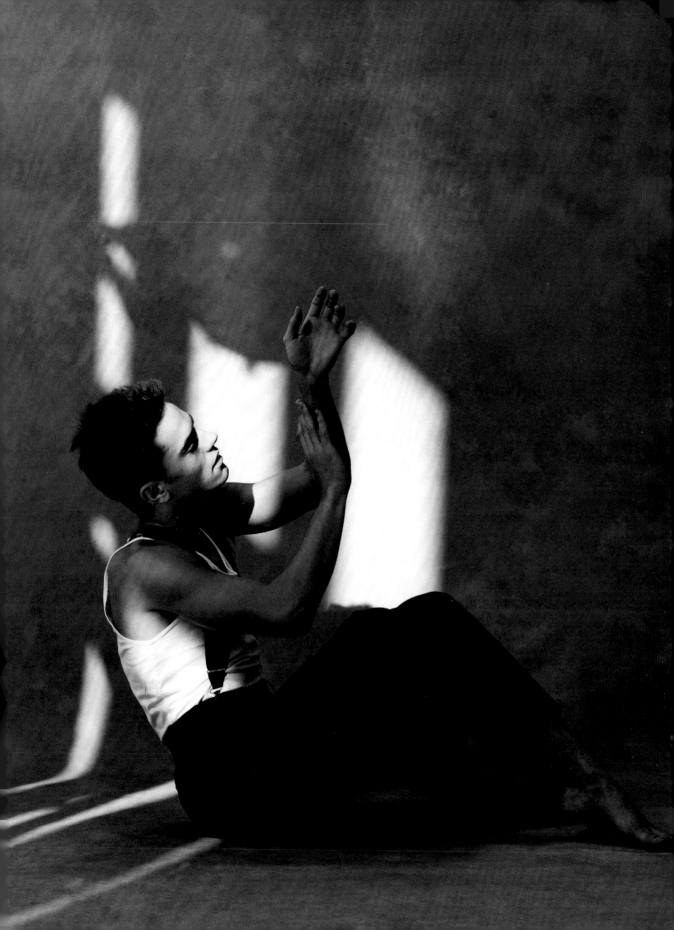

FORGET: LIGHTING

By this, I certainly don't mean ditch the idea of lighting altogether; photography is all about light, after all. What I'm specifically referring to are the outdated rules of thumb regarding lighting in photography, namely the following three directives I was taught in photo school:

≫→ OLD DIRECTIVE #1:
NEVER SHOOT INTO THE LIGHT

The logic behind this rule is pretty obvious: Shooting into the light or directly into the sun means a dark, backlit subject, with the ideal image having light hitting the subject from the front. Forget that! Shooting into the light means playing with the following cool effects:

– Striking silhouettes, particularly against the rich colors of the sky during dawn and dusk (make sure to expose for the background).
– Translucence in backlit, still objects like leaves, flowers, and stained glass windows.
– Rim lighting, or the faint illumination or halo of light, surrounding partially backlit objects shot at close range.
– Lens flares, which are a classic touch to nature shots and cityscapes.

≫→ OLD DIRECTIVE #2:
AVOID HARSH, MIDDAY LIGHT

We've always been told that early morning and late afternoon are the ideal times to shoot thanks to the low sun's mellow tones and long shadows. However, the harsh, midday light can sometimes lend just the right mood to your subject, and the compact, distinct shadows can work to your advantage. Besides, let's face it: Anyone can shoot a beautiful picture during the "magic hour." Trying for that perfect shot while the sun is high in the sky will yield more interesting and original results.

≫→ OLD DIRECTIVE #3:
USE FLASH IN DIM OR DARK LIGHTING

Back when I was in photo school, flash photography was all the rage, particularly for nighttime shots (which is commonsensical and understandable, especially considering the DSLRs we had at the time). Now, DSLRs have improved considerably and many new models are so powerful that they're able to pick up details even in the darkest of scenarios. (I've had great experiences shooting at night with the Nikon Df.) If you do feel like you need some extra light, try utilizing streetlights, the moonlight, or other existing light sources, however faint. See what it looks like to have that ethereal, "glowy," mysterious partial light shining directly onto your subject rather than the harshness of a camera light source. I've found that the full power of a camera flash generally makes the subject appear too bright, or "hot." (See also "Shoot at Night" on page 66 for more nighttime photography tips.)

FORGET: ACTIVE SPACE

The rule of active space states that if you're taking a picture of a moving subject, you should allow there to be more empty space in front of it ("active space") than behind it ("dead space").

It's fairly logical; this gives the viewer an idea of where the subject is moving and creates a sense of anticipation. As such, this compositional technique is generally applied to sports photography (i.e., cyclists, runners) and wildlife (animals in action).

 Personally, I think you get more intriguing results by doing the exact opposite. Photographing your subjects moving out of rather than into the frame creates a unique sense of movement and changes the narrative completely. Instead of wondering where they're going, the viewer questions what they left behind. As in the image left, it can convey speed and give the viewer a sense of where the subject has been rather than where they're headed.

CREATIVE SHOOTING EXERCISES

Inspiration ebbs and flows for even the most seasoned photographers, and sometimes you need a little help getting yourself through an artistic rut. Photography exercises like the ones you'll find in this section are a great way to switch up the routine and get those creative juices flowing again.

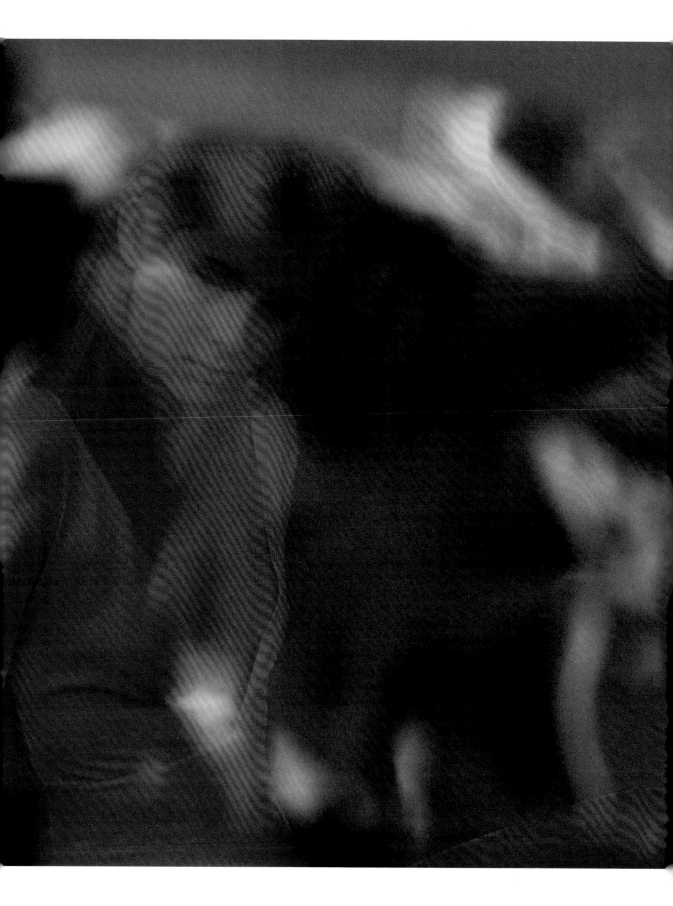

CHANGE UP YOUR GENRE

There are countless benefits to shooting outside your main genre. To name a few: It opens you up to new styles and influences, broadens your range, makes you a better photographer, and, mainly, it's just fun to try new things. For the purpose of this book, shooting outside your genre is also an excellent way to jump-start your creativity when you're bored with your camera.

It's simple: Just dedicate an entire day to shooting a completely different genre than the one you're used to. Take a look at the list left opposite and pick a genre or two to start with that is well outside of your normal range. You may even want to consider taking a class in a different genre that interests you (see also "Take a Photo Class" on page 26).

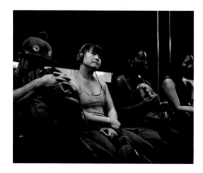

➤➤➤ **PORTRAITURE**
In a studio or in the subject's environment

➤➤➤ **STREET PHOTOGRAPHY**
Scenes of everyday life in urban, public spaces

➤➤➤ **NATURE PHOTOGRAPHY**
Natural scenery and landscapes

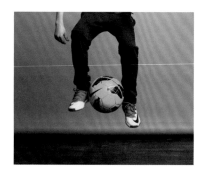

➤➤➤ **SPORTS PHOTOGRAPHY**
Athletes in motion

➤➤➤ **MOTION PHOTOGRAPHY**
General movement captured in a still image

➤➤➤ **ABSTRACT PHOTOGRAPHY**
The use of color, patterns, curves, and light to represent a subject in a non-literal way

➤➤➤ **BLACK-AND-WHITE PHOTOGRAPHY**
See "Shoot Black and White" on page 120

SHOOT AN ENTIRE ROLL OF FILM

When I'm feeling uninspired, one of my favorite things to do to get the creative juices flowing again is to shoot one roll of film. Besides certain aesthetic advantages, and the simple joy of going back to basics (more on this on page 116), shooting film and having a finite number of "shots" slows you down and forces you to think twice before snapping.

Think about it: A standard roll of film only has 24 exposures compared to the 10,000+ JPEGs you can store on a 32GB memory card! With so much freedom, it's easy to go nuts and rattle off hundreds of digital images without much thought. With only 24 shots, you're forced to be more methodical, more thoughtful, and to make critical decisions with every single shot.

In my experience, this exercise not only helps me to take better pictures, it also teaches me to value the process more, be a more thoughtful photographer, and to be more disciplined. (Not having to sift through thousands of hastily taken photographs afterward is an added bonus, too.)

Don't have a film camera? No worries: Head outside and shoot a pretend "roll" of 24 exposures. After 24, you're "out of film" and can no longer shoot. Simple.

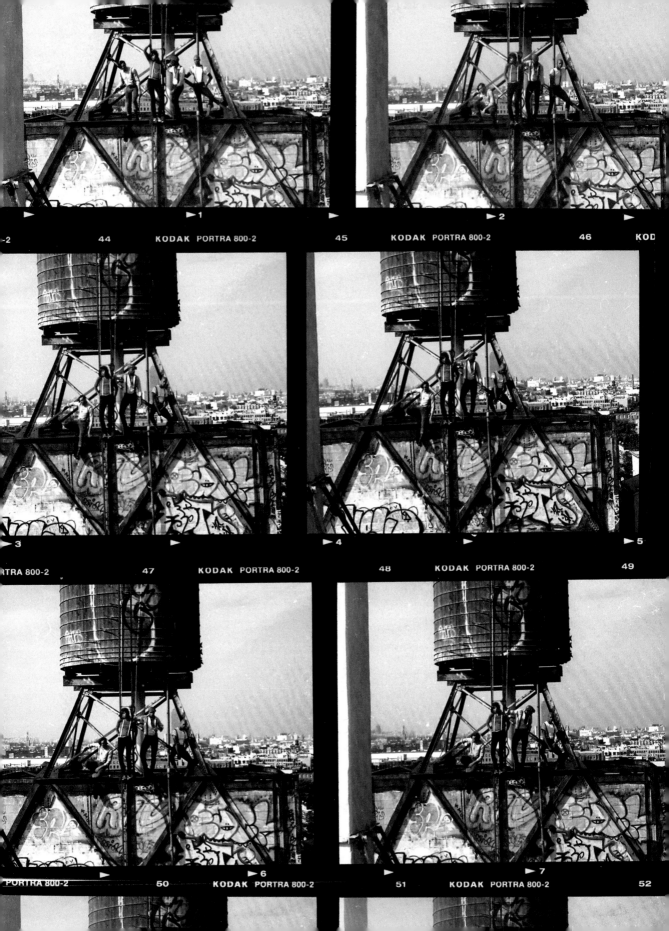

USE AN INSTANT FILM CAMERA

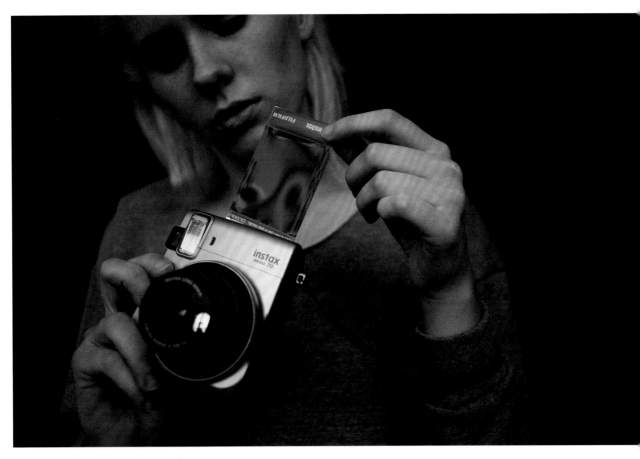

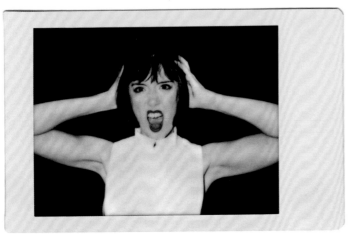

* **TIP:** If you're a professional photographer, take an instant film camera with you to set or on location. For every shot on your shot list, take an instant photo of it first—I find that the size restriction helps me figure out the true focal point in any scene. Plus it's just nice to have that immediate, tangible image, which I like to keep as a memento of the photo shoot for future inspiration.

Bored with your DSLR? Put it down and pick up an instant film camera. Though Polaroid is the most famous type of instant film camera, my camera of choice is the Fujifilm Instax. It's compact, cost-effective, you can find their film everywhere, and the photos come out amazing and surprisingly vivid and sharp. (The photos seen on these pages were taken with my Instax.)

Why shoot instant film? Well, there's the obvious: an instant film camera gives you the ability to hold your photos in your hand immediately. Instant film also makes everything look really cool and special, whether it's a portrait of a person on a plain white background or something mundane, like a cup of coffee or a bike resting against a brick wall. There's just something about the way instant film captures and distills a moment into a small, tangible, white-bordered photograph that makes you see the world a little differently. Of course, as with any film camera, you're working with a limited number of shots. I'm a big believer that restrictions breed creativity, and this particular exercise will force you to take photographs more carefully and thoughtfully.

Here's a fun exercise to try: Load up your instant film camera with a ten-pack of film and carry it with you for 24 hours. Throughout the day, take random shots as you go about your daily routine, always cognizant of the fact that you only have ten shots (make each one count!). At the end of the day, when you're holding those ten photographs in your hands, you'll be surprised at how much inspiration can be found in your everyday life.

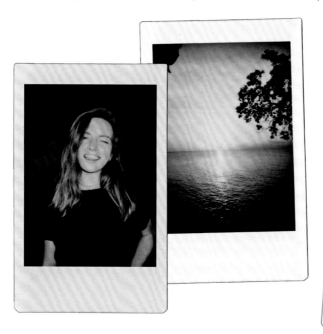

SHOOT DIFFERENT THEMES

A quick way to spice up your photography is to go out with a specific theme in mind and shoot only in accordance with that theme. Travel is great and I strongly encourage it, but you'll be surprised at how much inspiration there is right where you are when you train your eye to see something different. Pick up your camera and pick a theme:

⇶ DETAILS

Instead of photographing objects or people in their entirety, capture only specific details (i.e., hands rather than a whole person, an interesting architectural detail rather than an entire building). Sometimes, highlighting a single aspect of a scene is more powerful and interesting than the scene itself. Less is more!

⇶ REFLECTIONS

Look for natural reflections in glass, mirrors, puddles, rivers, in someone's sunglasses—whatever.

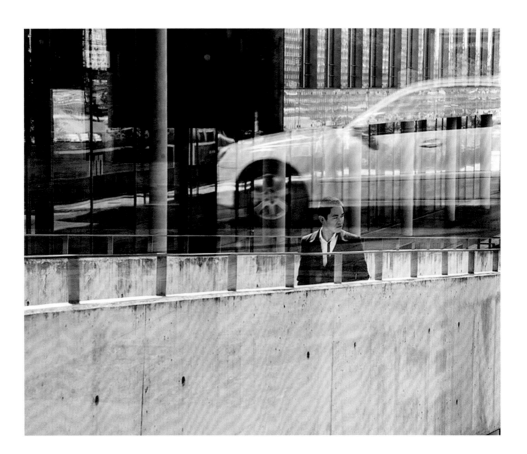

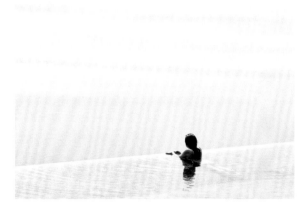

⫸ LINES

I love going out looking for lines. There are so many man-made and natural lines around us; it's incredible. Think roads, railway tracks, trees, stairways, skyscrapers, even the horizon. The list is endless. Keep an eye out for natural curves, too.

⫸ COLOR

Pick one color and go out and shoot only objects of that color.

⫸ SHAPES

Pick one kind of shape (start with simple ones like triangles, circles, or squares) and look for any instance where it occurs in your surroundings.

⫸ PEOPLE

If portraiture isn't your usual genre, then this is the perfect theme for you. Drum up the courage to shoot five random street portraits of people that look interesting to you. It might be awkward at first, but you need to step out of your comfort zone! It'll make you a better photographer (and probably a better person, too).

⫸ SYMMETRY

Look for symmetry in natural landscapes and urban spaces (there's a lot of striking symmetry in buildings and bridges, for example).

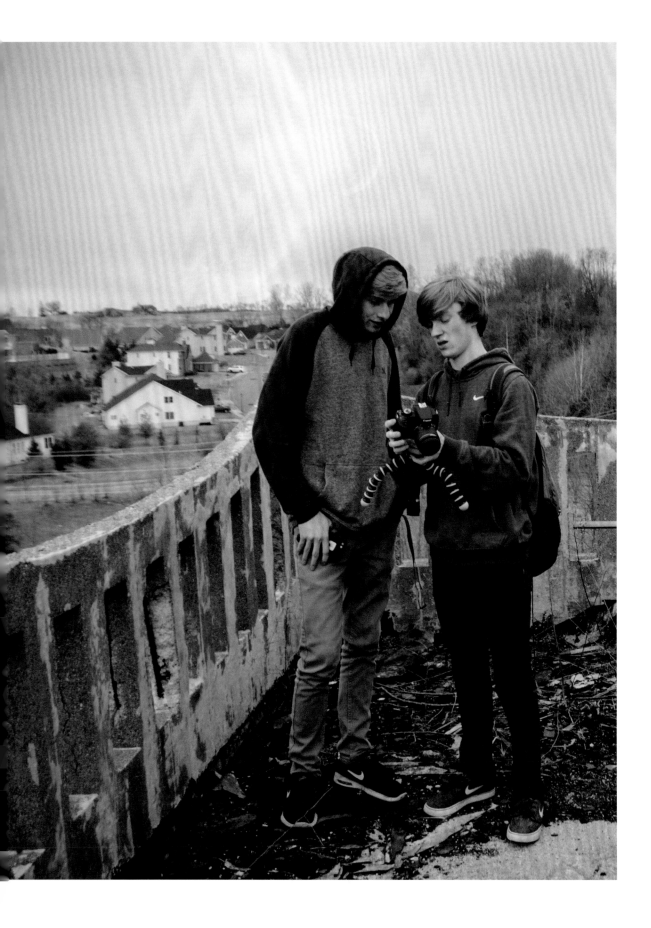

SHOOT WITH A BUDDY

I liken shooting with a buddy to having a workout partner. You're out there with someone who can hold you accountable and kick your ass. And hey, let's face it, it can be hard to get inspired when you're doing it all on your own. We all need a little help sometimes.

The best way to shoot with a buddy is by giving yourselves an exercise. Though any exercise in this chapter should do the trick, picking a theme (see "Shoot Different Themes" on page 52) is probably the easiest for two people to work on simultaneously. You'll be able to compare photographs afterward and give each other feedback.

Alternatively, you could simply choose a location that you both want to capture and go there together. It's always interesting to see how differently two people see and photograph the same location (plus, you can give each other a hand while shooting). Remember: Photography does not have to be a "lone wolf" activity! It can be more fun to shoot with a friend.

✳ TIP: Don't have a photographer buddy you can hit up? Contact your local photo association or go to Meetup.com. There are lots of photography groups all around the world (or you can start one).

EXPERIMENT WITH DOUBLE EXPOSURE

Bored of taking the same old pictures? Try your hand at double exposure. Double exposures are when two or more images are superimposed within a single frame. And no, I'm not talking about Photoshop. It's a technique where the shutter is opened more than once to expose the film twice, to two different images. The resulting image contains the subsequent image superimposed over the original.

Sounds complicated, but most manufacturers have added built-in double/multiple-exposure modes that automate this process for you (even some instant cameras, like the Fujifilm Instax, allow you to do this very easily). Once the mode is enabled, the camera will prompt you to take two photographs and the final result will be a combination of these images.

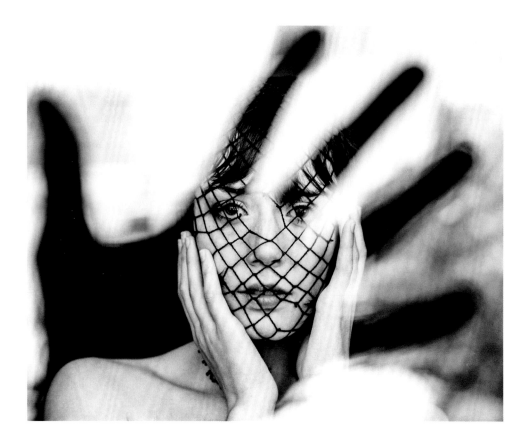

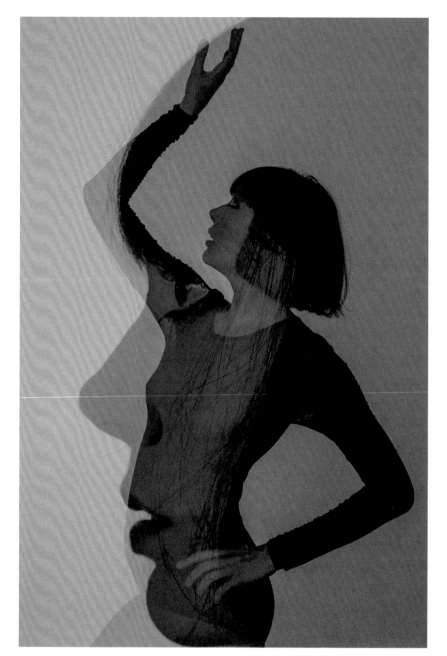

{1} Enable double-exposure mode on your camera: Make sure to shoot with your camera in Live View or via an electronic viewfinder, as many cameras allow you preview the entire process in real time. {2} Capture the silhouette of a person as your original image: Make sure they are as dark as possible for this step; the easiest way to do this is have them stand in the sun or in front of a bright light. Also make sure that your background is as light and blown out as possible in order for the second image to later "fill" the underexposed silhouette. {3} Take your second image: I'd suggest using abstract patterns or natural patterns like leaves, sand, ocean, or flowers for the most interesting results. {4} View the results and see the way the photographs interact with one another: It may take a few tries before you get it right, but once you get the hang of it, you'll be able to create some really surreal, unique images.

SHOOT IN ONE SPOT

Traveling or taking a walk are great ways to jump-start the inspiration engine when you're bored with your camera, but for this exercise you're going to do the exact opposite.

Find a busy street corner—preferably one where people are coming at you from all directions—and find a spot that's ideal for people watching but is not obtrusive to others. Plant your feet on the ground or find a spot to sit, stay as still as possible, and just take pictures.

There are no limits to what you photograph; snap whatever strikes you as interesting. The only rule is that you don't move your feet for at least 30 minutes. This is an interesting exercise because you're not chasing down subjects or photo-worthy opportunities for once; they are all coming to you. You'll also learn to be more patient—one of the most underrated virtues in photography.

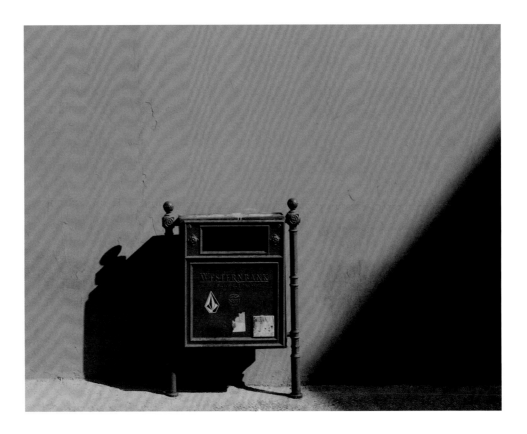

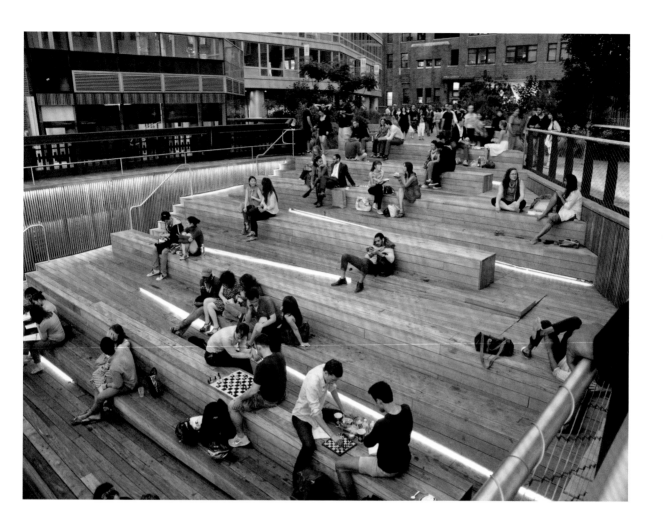

You're forced to really look at your surroundings. You'll see things you wouldn't have seen if you had just stopped on the street corner for a second to take one cool photo. You're forced to think outside the box, as well. Being stuck in the same spot for an extended period of time will encourage you to see new possibilities and try different techniques—at the very least, so you don't end up with a thousand versions of the same few images. (Reading "Forget the Rules" on page 28 before this exercise might help.)

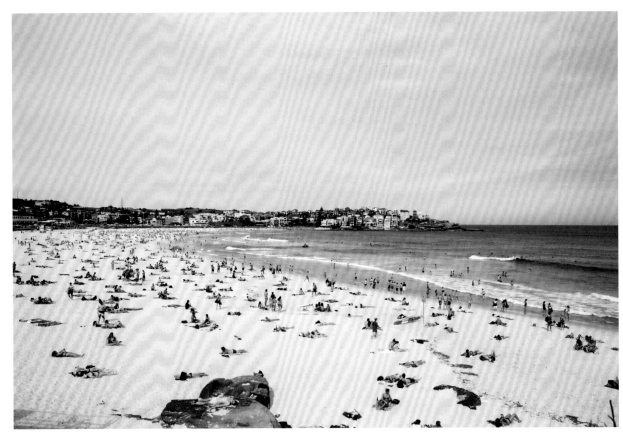

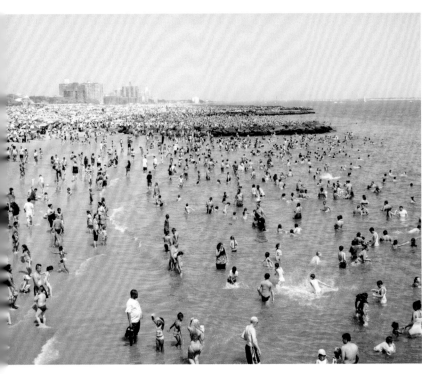

SHOOT A LONG-TERM PROJECT

Short-term shooting exercises can be exciting and instantly gratifying, but long-term shooting projects (those that take more than a year) are infinitely more rewarding and even life-changing if you commit to something you're truly passionate about.

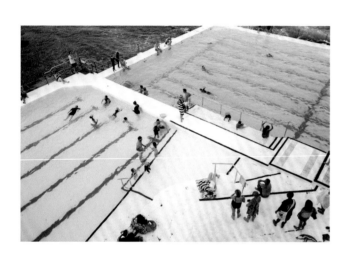

To begin with, pick a subject. Picking a good one is crucial to the success of your project. Start with a list of subjects or ideas that are interesting to you (if you're stuck, refer back to your Inspiration Board; see page 11) and then narrow it down to the one that speaks to you the most. The key here is finding something that you're naturally interested in—preferably passionate about—otherwise you'll get weary of the subject and, eventually, bored of the entire project.

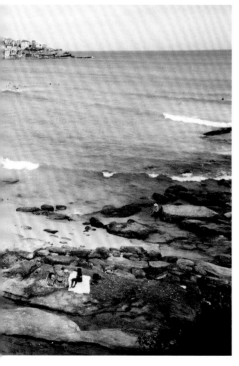

Can't find a subject you want to shoot over an extended period, or simply don't believe that a long-term photo project is even feasible for you? I get it. I've been there. That doesn't mean you shouldn't do it! Start with something that's easily accessible to you. You might just be surprised at how invested you become as the project goes on. When I was in photo school, for example, I was forced to shoot a long-term project as an assignment. Perhaps it was a bit lazy to put the assignment off until I spent a summer near the beach, but these photos (opposite) are still some of my favorites more than a decade later. For your long-term assignment you could pick one of the following project ideas:

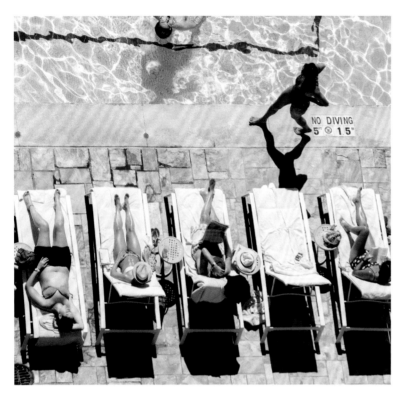

⫸ A SINGLE THEME

Anything that sparks your interest, however random. I've seen a beautiful long-term project on clouds with amazing results, a fun series on goofy signs, and another capturing aerials of people sunbathing on beaches all over the world.

⫸ STRANGERS

A friend of mine told me about the "100 Strangers" project, in which you take portraits of 100 complete strangers who have given their consent to be photographed by you, essentially forcing you to interact with 100 people you've never met before and take their photograph.

⫸ A PERSON

Document the way a person—or even set of people—changes over time (one of my favorite examples of this is Nicholas Nixon's "Brown Sisters" project, a photo series of four sisters over a period of 40 years). Self-portraits also fall into this category.

⫸ A DESTINATION

Photograph your street, a neighborhood, an intersection, a landscape, and how it changes over a year or longer.

⫸ LONG EXPOSURES

And I mean looooong exposures. Photographer Michael Wesley captured three years of construction in New York City by leaving the shutter open for three years!

⫸ PROJECT 365

Ok, it's not terribly original, but if you're at a complete loss, taking one photo a day for an entire year is a solid jumping-off point.

PAINT WITH LIGHT

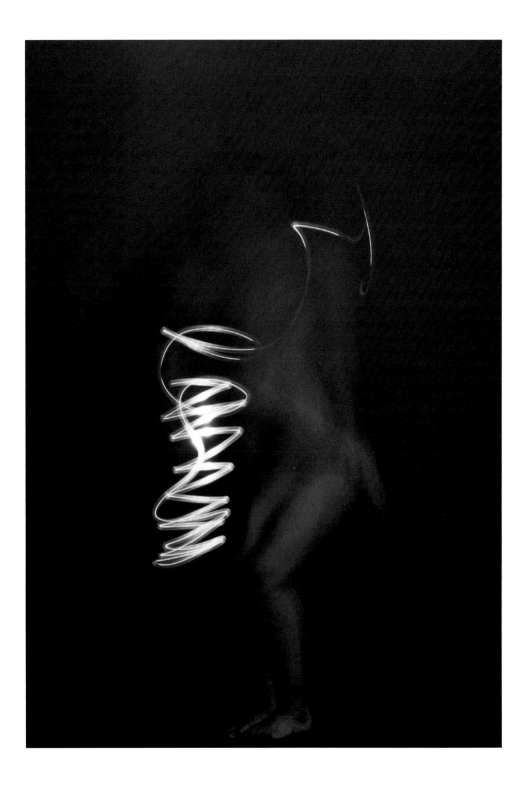

One of my favorite photo techniques is painting with light. You get gorgeous pictures but mainly it's just fun and gives you a break from routine. Light painting is exactly what it sounds like: you're using light as a "brush" to paint pictures, write words, and create cool effects within a photograph.

≫→ WHAT YOU'LL NEED:
– A DSLR or a camera that is able to shoot long exposures and has aperture and ISO control
– Tripod
– One or multiple light sources to "paint" with; any light-emitting device will do, like a flashlight, laser pointer, glow stick, or even a cellphone in a pinch
– A dark location

≫→ HOW TO DO IT:
{1} Set your camera on a tripod, angle the camera, pre-focus on your subject if you have one, and take a sample shot with the flash and lights on (this will help ensure that you composition is on point).

{2} Plug in the following settings. (This can obviously change and you should experiment with different settings. Simpler light drawings normally take around 10 seconds, while more complicated ones can go 30 seconds or longer, but the below is a good starting point.)
– Shutter speed: 30 seconds
– Aperture: ƒ/11
– ISO 100

{3} Trigger the shutter. Once the shutter is open, use the light source to "paint" stuff inside your frame: words, streaks, swirls, your name—heck, you can even "graffiti" a landscape. If you have a subject, you can use the light source to expose that subject by pointing the source directly at it (kind of like a flash). Otherwise you can paint on it or around it. In this case (left and opposite), I used a model to paint with light and mixed in some double exposure (see "Experiment with Double Exposure" on page 56). There are endless things you can do with light painting. You're only limited by your own creativity!

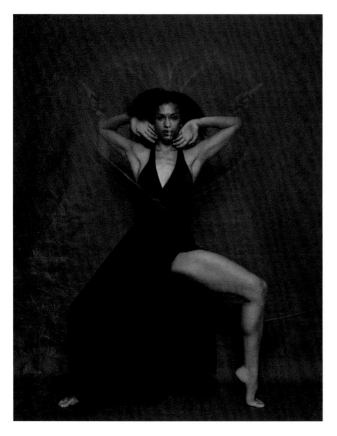

SHOOT AT NIGHT

As photographers, we're all taught that light is our best friend, which is why many photographers take their shots during the "magic hour" and then call it a day ... but after the sun goes down is when the real magic happens! Shooting at night is a fun, exciting exercise that allows you to see the world in a totally different way and create awesome, dramatic images you won't be able to get any other time of day.

You'll need a tripod and a cable release. Longer exposures require a very still camera and a cable release will minimize camera shake when you trigger the shutter (though you can also use your DSLR's timer). I also recommend a wide lens and an external flash (optional).

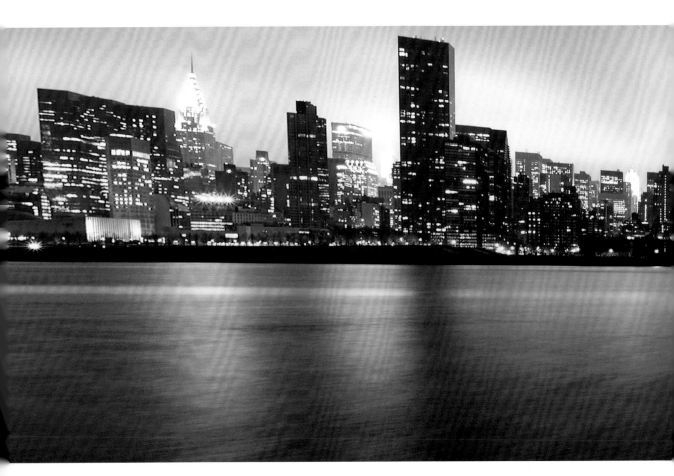

Once you've got your gear ready, pick a location, set up your tripod, put your camera in Manual mode (Auto or even Night mode simply won't cut it), set your aperture and shutter speed for night shooting, and start taking interesting photos!

Some cool things to photograph at night:
– Skylines
– Ferris wheels
– Star trails
– Light trails on a busy road or highway

✳ **TIP:** Keep your **ISO** at a normal level rather than bumping it up, close down your aperture rather than opening it up, and shoot a much longer exposure. I'm a big fan of long exposures for nighttime shooting to avoid noise. If you need more light, just lengthen the exposure time.

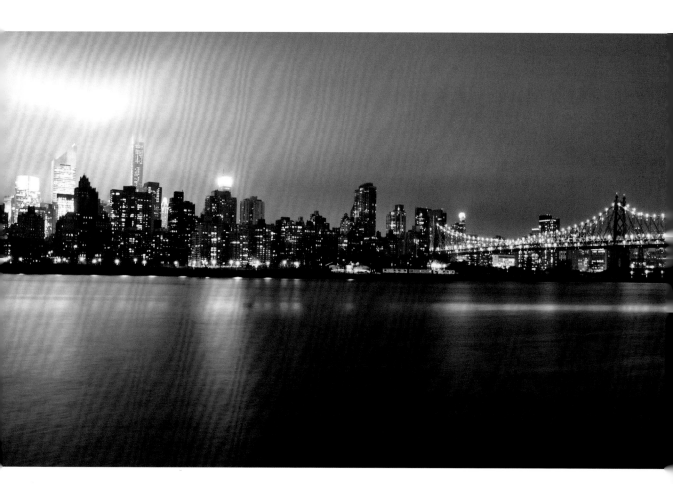

SHOOT ACTION

Unless you're a professional sports photographer, you're not likely to be shooting a lot of movement or action in your day-to-day photography, but knowing how to effectively capture movement is a good skill to learn—not to mention a fun challenge.

While sports games and events are the obvious place to practice, they're also crowded and require a lot of pre-planning and preempting where the action will be (plus athletes are lightning-fast and not the best subjectsto practice your initial photographic timing on). Start off by sitting in on a ballet or hip-hop class instead. Visit a skate park and capture people doing skateboard tricks. Photograph a friend riding a bike, or make images of your kid playing in the backyard. These situations are much more forgiving when you're experimenting with action shots for the first time, plus you'll get infinitely more interesting images than just shots of athletes running around a field.

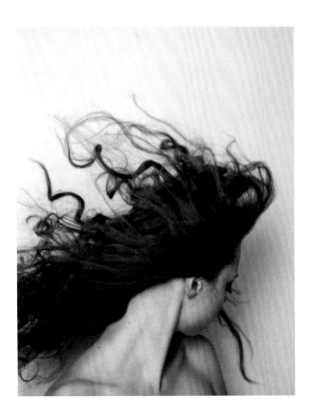

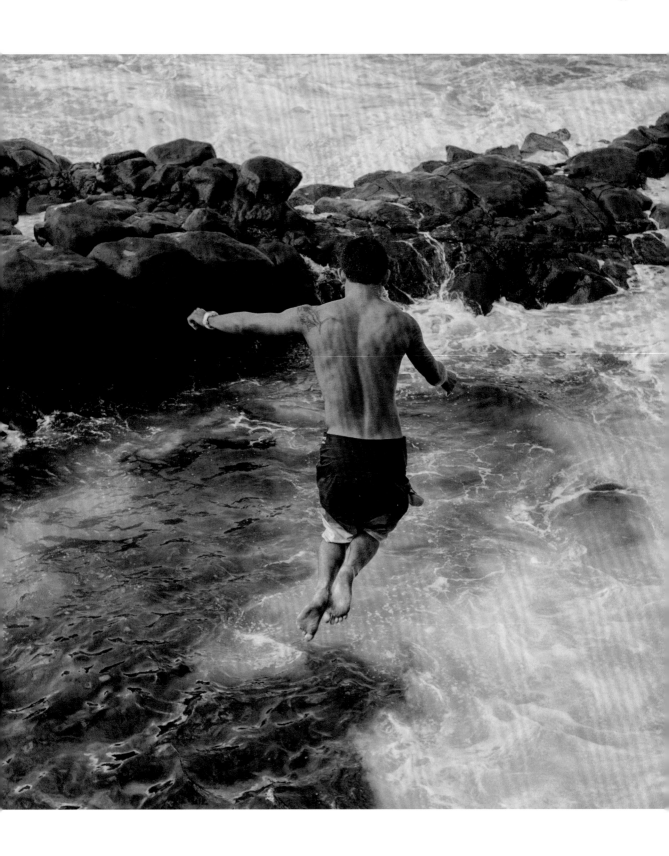

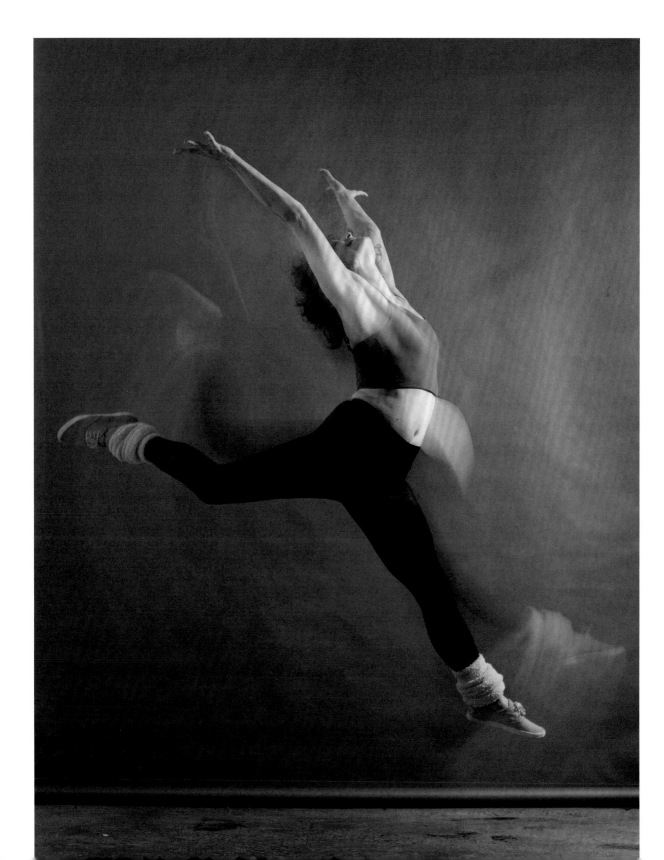

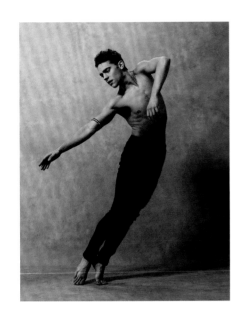

A few key tips for shooting action:

⫸ PRE-FOCUS

Pre-focusing means locking the focus of your camera to the scene where you want to take your shots (consider using autofocus to lock onto the spot, then switch to manual focus so that you stay focused on that spot). This will help lower the lag time between triggering the shutter and the actual taking of the image.

⫸ DETERMINE THE PROPER SHUTTER SPEED

Every situation is unique; there's no "one speed fits all" for action shots. To identify the right shutter speed, ask yourself how fast the subject is moving, how much distance exists between the camera and subject, and how much motion you want the image to convey to the viewer. The faster the shutter speed, the more frozen and sharp your subject will be. (Most cameras today will allow you to freeze a scene using 1/8000th of a second or faster.) Experiment with different shutter speeds in a variety of situations.

⫸ PANNING

Panning—following your subject with your camera as you snap the photograph—is a great way to capture action. I've found that panning actually helps take clearer photos of a subject in motion than photographing it while you're holding still, as you are matching the speed of their movement.

⫸ SHOOT IN SHORT BURSTS RATHER THAN ONE LONG BURST

Turn your camera to continuous High-drive mode and shoot the action in several short bursts. (I shoot three or four short bursts, wait a second, and then start shooting another burst.) This helps to prevent your buffer from filling up.

RESTRICT YOURSELF

Restrictions breed creativity, and that is a fact. As with life in general, unlimited time and resources can often make you lazy and sloppy. By placing artificial restrictions upon yourself, you're introducing a new rule or set of rules that cannot be changed. As a result, you're forced to find a creative workaround, explore new possibilities, and, ultimately, grow as a photographer.

Try one or more of the following creative constraints:

⟫→ RESTRICT THE NUMBER OF SHOTS YOU TAKE

Digital memory is cheap these days and you'll never have to worry about running out of space for pictures, but pre-digital era, photographers were limited to just a handful of shots at a time and they still managed to capture iconic images. Channel the greats and limit yourself to just 36 shots in one session. Be more measured and intentional by taking the time to study each frame and find the worthiest shot. Most importantly, shoot for quality and not quantity! Once the 36 have been taken, put the camera down.

⟫→ RESTRICT YOUR TIME

If you're anything like me, I work best under time pressure. When I'm on set for a shooting job and the clock is ticking, my mind switches to a completely different mode and I'm forced to think and shoot fast (and well). Go for a photo walk and allow yourself only ten minutes to find that one perfect photo. Once the time's up, put the camera down. Conversely, you could force yourself to stay in one spot for an extended period of time—not moving for an hour on a busy street corner (like you did in "Shoot in One Spot" on page 58)—which opens up a completely different set of possibilities.

⟫→ RESTRICT YOUR SUBJECT MATTER

This might sound similar to shooting one specific theme, but this is going a step further. Here, you're not just shooting, say, buildings; you're shooting just one building over and over again. Study it from every possible angle; find ways of positioning yourself to capture perspectives that are not so obvious or cliché. Try returning at different times of day or on different days of the week and see how that building changes with light. You might end up with hundreds of pictures that are uninteresting to you, but you'll also likely end up with some incredible shots that you wouldn't have accomplished without a creative constraint.

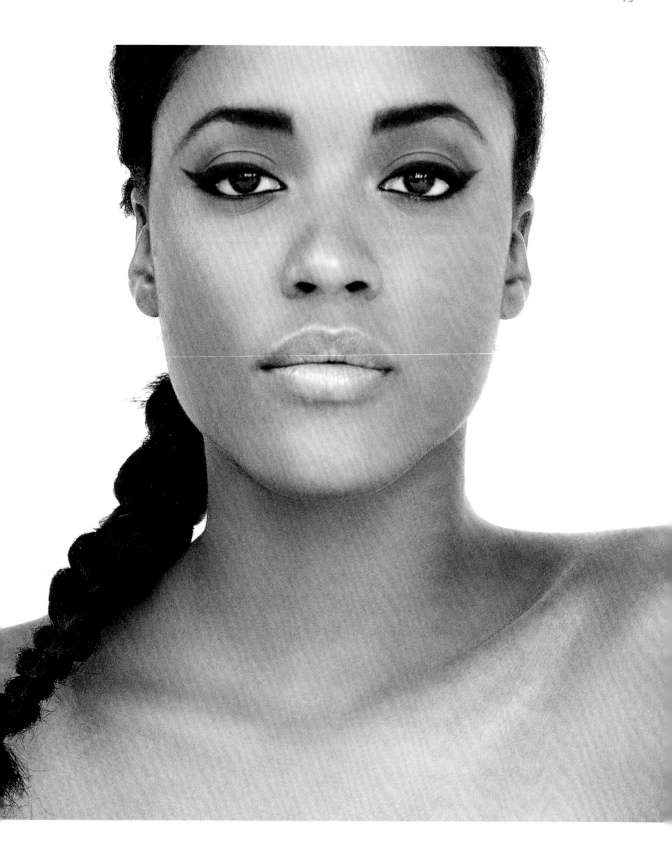

SHOOT STILL LIFE

Unless you're a professional product photographer, photographing static objects is probably not your genre of choice. To begin with, it takes a lot more effort than just showing up and shooting an existing scene; you are essentially staging the scene yourself.

Unlike landscape or portrait or street photography where the subject matter is dynamic and has many variables, a photographer has complete responsibility and control over their subject in a still life shoot, which in turn is much less dynamic and has fewer variables, making it an excellent photographic challenge.

All you need to try your hand at still life is a simple space, such as a table placed by a window, along with a simple white backdrop and a couple of lamps. What you photograph is completely up to you but you might want to start by shooting one simple, interesting object to start with. (If you take one thing from the exercise let it be this: Still-life photography does not have to be of fruit and flowers!)

Once you've gotten the hang of that, try arranging objects of contrasting shape, color, or texture together on the same backdrop in a way that looks interesting to you. You can also experiment with camera angles, lighting angles, and alternative light sources such as candles to create different artistic effects.

PLAY WITH ON-CAMERA FILTERS

Call me a purist but I still think there's a lot to be said for—and fun to be had with—traditional filters. Sure, these days you can just apply effects to your images in Photoshop, but nothing beats messing around with physical filters while you're actually taking pictures. Give the following filters a try (you can often rent these at your local camera shop):

➤ POLARIZING

Polarizing filters block out polarized light, dramatically reduce reflections, enhance colors, and turn up the contrast in your images. Using a polarizing filter when photographing a landscape can intensify natural colors, produce sharp contrast between clouds and sky, and even reduce haze for a more powerful image.

➤ NEUTRAL DENSITY (ND)

Easily one of the most underappreciated filters, ND filters reduce the amount of light entering the lens— kind of like a pair of sunglasses—without affecting the color. This allows you to slow your shutter speed down slightly, enabling a longer exposure time. This is useful for situations where motion blur needs to be created (such as with moving water), so an otherwise tumultuous scene will appear silky and surreal. Alternatively, an ND filter also allows for larger apertures, which can produce shallower depths of field or achieve sharper photos.

➤ COLOR

Color filters (which include cooling and warming filters) are generally used to alter the camera white balance. There are two types of color filters: color correction, which corrects white balance, and color subtraction, which absorbs one color to let other colors through. Though many photographers consider these filters out of date now, I think digital filters don't always produce the same results that physical filters do.

⫸ CLOSE-UP

Primarily used in macro photography, close-up "filters" (which are technically lenses, not filters at all) allow a lens to get closer to the subject by decreasing the minimum focus distance of the lens. These screw-on lenses are a cheap way to convert your normal lens to a macro lens. I love shooting leaves or flowers with a close-up filter, just for fun.

⫸ SPECIAL EFFECTS

These include star filters, which make bright objects in an image look star-like; fog filters, which add a soft, dreamy glow to your images; and multi-vision filters, which create multiple copies of a subject.

DO A TIME LAPSE

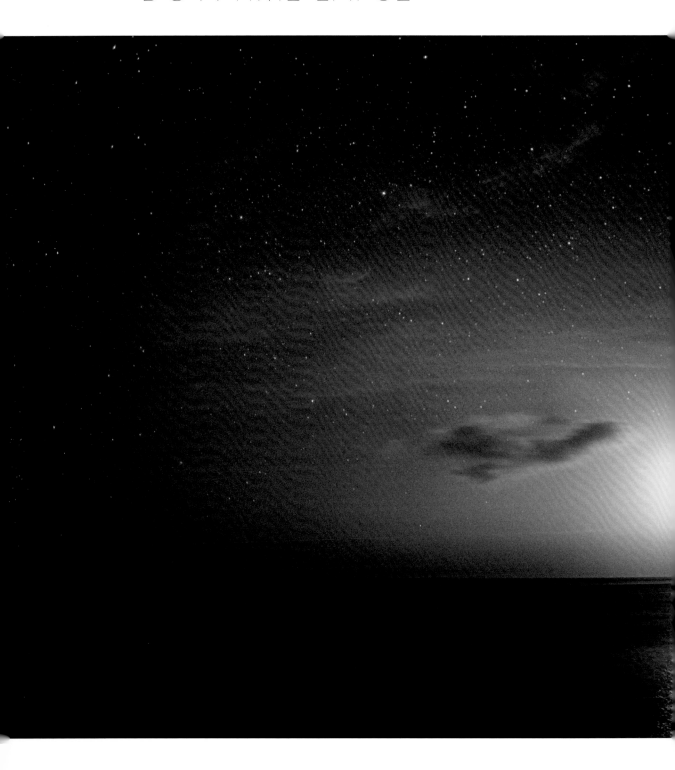

Time-lapse photography is inherently inspiring. There's something about the patience involved, the delayed gratification, the anticipation of the outcome, and, finally, the fulfillment of capturing a changing landscape that just takes photography to a whole other level.

That said, the process itself doesn't sound quite as sexy on paper. Basically, you're shooting the exact same scene over and over again, over an extended period of time, and then combining all those photographs to create a short film sequence that reveals the progression of time. As a result, an event that would normally take several minutes or hours—or even months, if you're willing to invest that much time in the project—can be viewed in just a handful of seconds.

What to shoot:

– Sunrise or sunset
– Ice melting
– A busy street
– A desert sky
– Slow-moving clouds
– Cookies baking in an oven
– A stadium filling up with people
– Boats coming and going from a marina
– A construction site
– The Northern Lights
– The tide

TIME-LAPSE EXERCISE

⫸➤ WHAT YOU'LL NEED:
- A camera
- A tripod
- An intervalometer (an automated camera trigger that you can program to snap hundreds of photos at precise intervals)
- ND filters (like sunglasses for your camera, these filters reduce the intensity of light without altering its color)

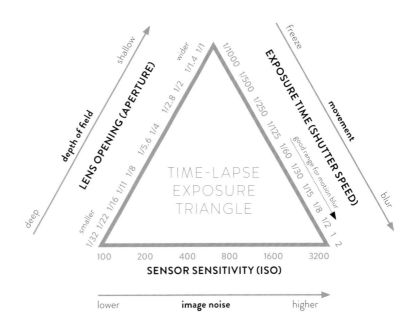

⫸➤ HOW TO DO IT:

{1} Get your composition right: To ensure an interesting and visually dynamic time-lapse composition, make sure to have constant stationary elements that anchor the frame (such as a beach or mountain in the foreground of a sunset) and aim for high contrast between the constant and "moving" parts of the frame.

{2} Program the intervals: Figure out how long the intervals should be between shots based on your subject. For example, if you're filming fast clouds on a windy day, the intervals should be relatively short in order to keep yourself from losing too much information between shots and producing a jerky, abrupt time-lapse. Conversely, if you're filming very slow-moving clouds, you certainly don't need shots taken at one-second intervals but can set it at 10 seconds or even longer.

{3} Get your exposure right: Control your exposure to minimize the "flickering" you can often get in a time-lapse due to slight differences in exposure between shots. Switch to Manual mode and refer to the time-lapse exposure triangle opposite. (If worse comes to worst, software programs like LRTimelapse can also help remove flicker afterward.)

{4} Shoot: Get a few fun tests under your belt and experiment with different subjects. Remember, this exercise is about having fun and trying a new technique, not getting a technically perfect time lapse.

✳ TIP: Make sure the batteries are all charged up with enough juice and that your memory card has enough room! You don't want to run out of battery or memory just as the sun sinks into the horizon.

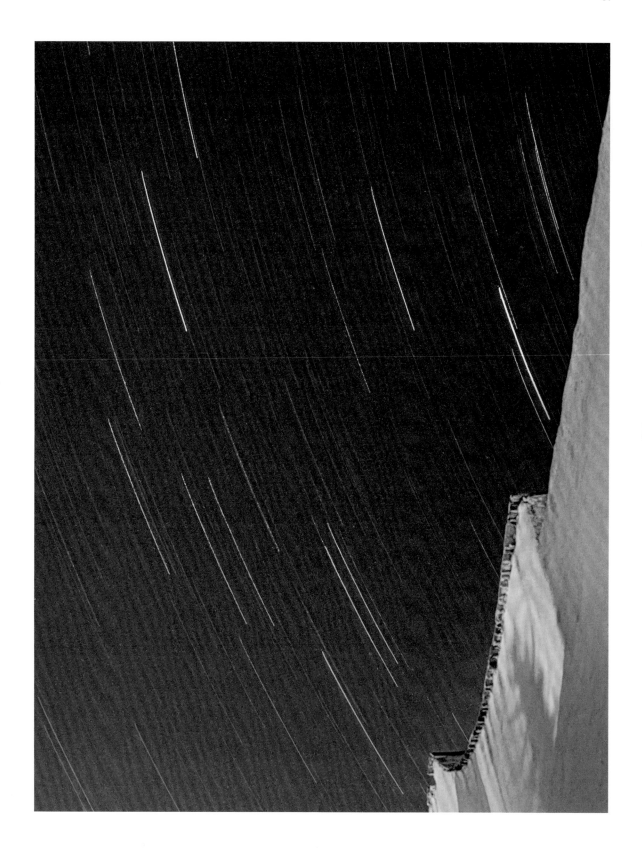

CHANGE YOUR PERSPECTIVE

Shooting at eye level is the default position for most photographers. By simply playing with perspective, however, you can change the story behind an image and make it immediately more interesting.

Find one subject and use it to try the following exercises in perspective:

⇛ GET LOW

Shooting from a low angle—with the camera placed below eye level, lens pointed upward at the subject—changes the narrative of your image almost instantly, making the subject before you seem taller, more powerful, and more commanding, transforming even already tall subjects like a tree or building. Getting low can also reveal the immediate foreground of your frame, which can help add context to an image.

⇛ GET HIGH

Shooting from above—with the camera placed above eye level, lens pointed down at the subject—changes the narrative of your image just as effectively. In this case, subjects look smaller and more vulnerable; you are in a physically "superior" position. Depending on the context and application of other techniques and effects, it can make a viewer feel very powerful and omnipresent, or even impart a feeling of surveillance as if you are watching the subject, Big Brother-like, from above.

⇛ FORCED PERSPECTIVE

We've all seen those images: someone seemingly "holding" the sun in the palm of their hand or "pushing over" a landmark like the Leaning Tower of Pisa with a finger. Such optical illusions are created using the technique of forced perspective, which makes an object appear farther away, closer, larger, or smaller than it actually is. There's no one "correct" way to do it; you simply have to experiment and get creative about the positioning of objects, the correlation between them, and the vantage point of the viewer.

✳ **TIP: Feeling ambitious? Try your hand at drone or aerial photography and get really high up there. Just make sure you know and abide by local regulations as in many countries, drones are viewed as "unmanned aircraft."**

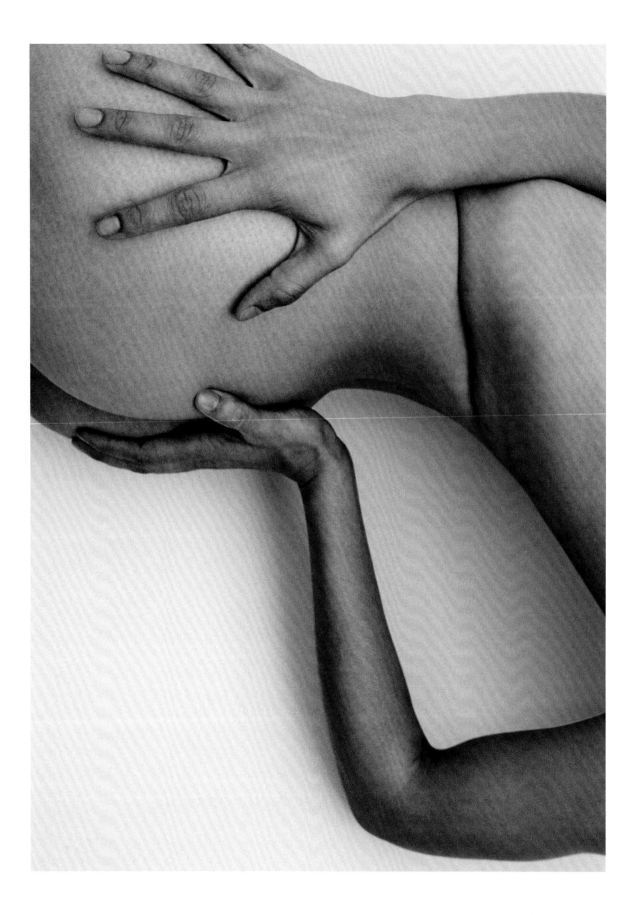

PLAY WITH HARD LIGHT & SOFT LIGHT

We photographers are always obsessed with finding the perfect light, but I have always found my images to be more interesting when the light has been anything but perfect. Though the rules of photography teach otherwise, I recommend experimenting with shooting in non-ideal light situations. You may just surprise yourself and, at the very least, it's a fun challenge. In either case, don't be afraid to go for a look you may not be used to! (See also "Forget: Lighting" on page 41.)

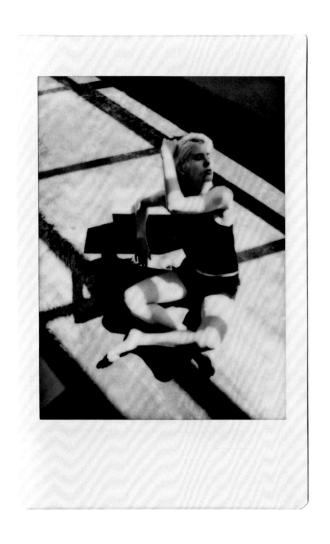

⫸ SHOOT IN HARD LIGHT

Find a subject to shoot and go out at one or two in the afternoon to shoot it. Find a way to utilize the strong shadows and the high contrast in a way that is artistic, or that might convey a certain mood or meaning. Instead of shying away from the hard edges and greater definition, look for creative ways to play it up. If you're in a studio, try using a grid or snoot as a main light (which keeps light localized) or shooting directly in front of a window at midday. Play with different subjects and see which ones are best suited to hard light. I find architecture to be an ideal hard-light subject.

⫸ SHOOT IN SOFT LIGHT

Shoot the same subject in soft light, which you can find in the shade on a sunny day, during twilight, or all around you on a cloudy day. Using a reflector between the light source and the subject can also help to soften the light and cast diffuse shadows with soft, gentle edges. If you're in a studio, try shooting with a soft box or umbrella, though really, shooting by a window where the natural light streams through a curtain will do the trick for these purposes. Again, play with different subjects and see which ones look best with a distinctly soft, luminous quality. I find portraits especially flattering in soft light.

PLAY WITH SHADOWS & HIGHLIGHTS

Shadows and highlights aren't just by-products of light (or lack thereof) in an image; they are striking photographic opportunities in and of themselves. Pick a subject (preferably a person, though an intimate object can be interesting as well) and position that subject near a window with some nice natural light streaming in.

Take the following five shots, carefully considering each point before taking the shot:

– How can you use existing shadows and/or highlights to ramp up contrast and drama in the image?
– How can you manipulate shadows and/or highlights to amp up contrast and drama in the image? (For example, you can move around the subject and add or subtract light.)
– How can you use shadows or highlights to direct a viewer's attention toward your subject?
– How can you use shadows or highlights to accentuate shapes, textures, or details? (Think about how shadows can bring out ripples in sand dunes.)
– How can you use shadows or highlights in an unconventional or abstract way? (Take the photo opposite of a palm tree, where the shadow itself has become the subject.)

SHOOT THE MUNDANE

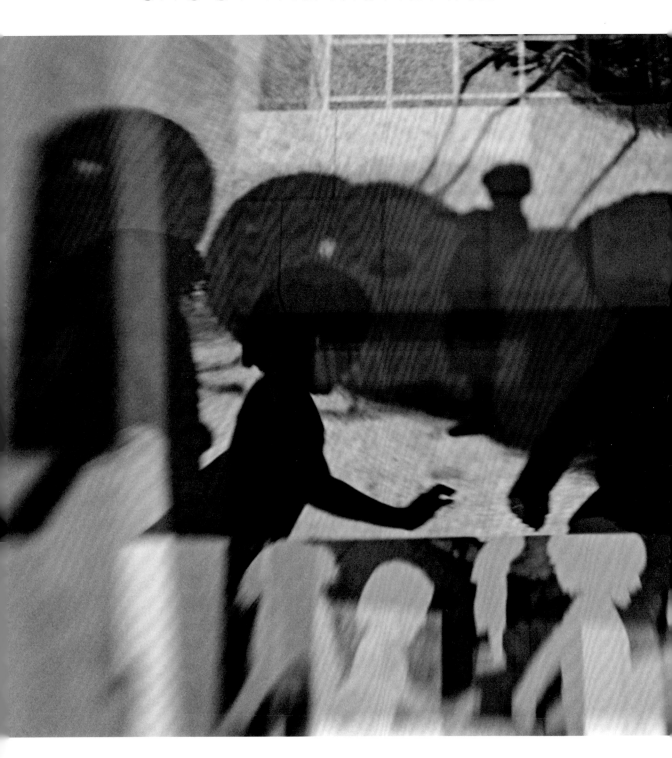

Sounds counterintuitive to shoot the mundane when you're already bored with your camera, right? But the mundane isn't as, well, mundane if you train yourself to see it with fresh eyes. Walk around your block and find yourself a subject that you would normally consider boring.

This time, before you pick up the camera to shoot it, think about the following first:

⟫ COLOR

Forget the subject in its entirety. Forget the subject's context. What if you saw that thing in terms of purely color? What would you see? Is there a story, however abstract and non-literal, in that subject's colors? What do its colors (or perhaps lack thereof) tell you about the subject?

⟫ LIGHT

Look at the way light interacts with your subject. Is the light hard or soft? Does it cast any interesting shadows? Can you somehow utilize existing light or manipulate light to ramp up drama and contrast?

⟫ TEXTURE

Picture the subject in front of you as if it were in black and white. What textures come out at you? Are they man-made or natural? Soft or hard? Smooth or rough? Do these textures tell a story? Could you find a way for these textures to create a compelling abstract image? (It might even be worth using a close-up filter or macro lens for this.)

⟫→ JUXTAPOSITION

Look for opposing elements in the subject before you and the context that surrounds it.
Examples of opposing elements include light and dark, old and new, smooth and rough.
Study the interplay of these contrasts. Do they create any tension or drama or complexity?
How can you play this up?

⟫→ DETAILS

Oftentimes, the story of a subject is in the details. Forget your subject as a whole and instead
look for its cracks or scars or wrinkles or patterns or reflections or oddities. Even something
as simple as a single leaf is blessed with so many amazing and significant little details that you
can capture—its veins, its textures and colors, droplets of dew. A close-up filter or macro
lens can help to enhance such details.

⟫→ ANGLE

Changing your angle can dramatically affect the way you see a subject and the story that
it tells. For example, a dull, nondescript building at street level might take on a whole new
dimension of beauty from the roof of a building opposite. Perspective is very powerful.
(For more exercises on perspective, see "Change Your Perspective" on page 82.)

Remember, any good photographer can take a beautiful photo of a beautiful subject.
A great photographer will be able to take a beautiful photo of any subject.

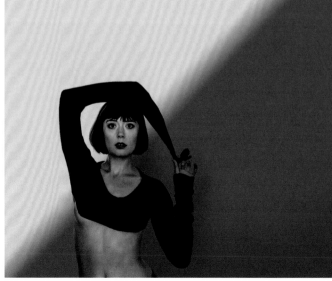

USE PROPS

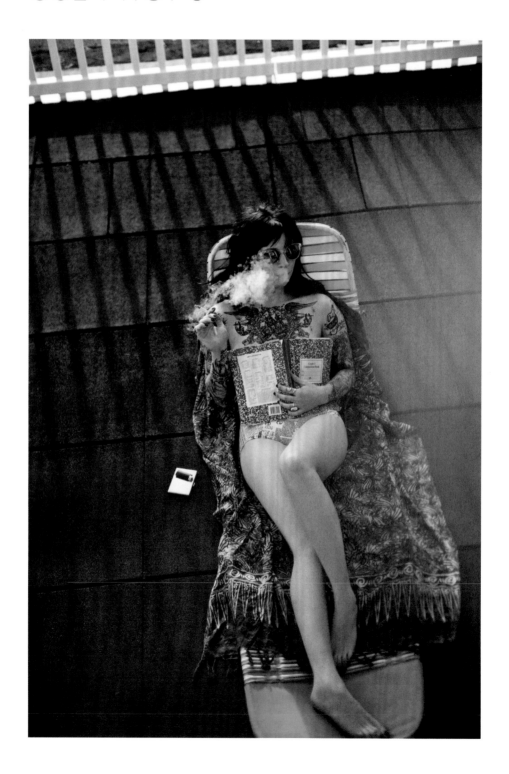

Props can get a bad rap for obvious reasons; when not used properly, they can make an image look staged, posed, and unnatural. When done correctly though, a little extra something can add ... well ... a little extra something! It's all about using props that have a purpose, appear to interact naturally with your subject, and enhance the image in some way.

Pick a subject to shoot (preferably a person) and think of how a prop might be used to:

⫸ CONVEY CHARACTER

What object/s can you introduce to the frame that can make the viewer better understand the personality of the subject—their mindset, their mood? Even the introduction of a chair, and the subject's interaction with it, could be telling. What object/s can you introduce to help depict the kind of life they live?

⫸ ENHANCE ENVIRONMENT

What object/s can you introduce to better enhance the context of a subject? Consider using environmental elements as props: an artist in the studio with their paintbrush, a farmer leaning against his tractor. The prop should not be so obvious that is becomes the focal point of a photograph, but rather it should simply enhance or help tell the story.

⫸ INFUSE CONTRAST

Don't be afraid to take risks! Yes, ideally a prop should fit naturally with the subject and its context, but rules are made to be broken. Playing with juxtaposition when applying props to a scene can yield interesting and striking photographs. For example: a classic, straight-laced subject with a modern, edgy prop; or a graceful, feminine subject with a masculine, industrial prop.

✳ **TIP:** Don't use more than one prop and try to keep the rest of the image as clean as you can with minimal distractions. Remember, using a prop adds another level for the viewer to process, so simplicity in composition is key.

USE BOKEH

Bokeh—the aesthetic quality of a photograph's out-of-focus or "blurry" areas—is a great way to add a little pizzazz to your images when you're bored with your camera. When done properly, bokeh makes certain parts of an image (usually the background) look soft, fuzzy, and pleasing to the eye, and it also helps to train the eye to focus on a subject.

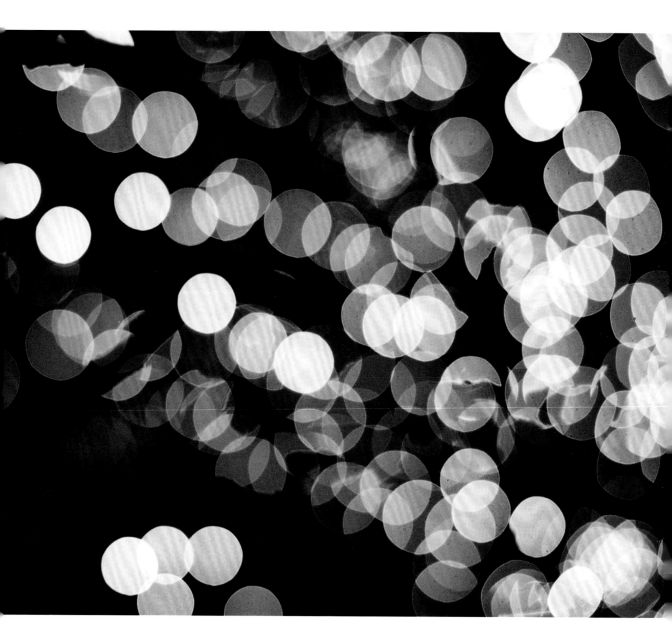

Never done it before? Here's a quick tutorial:

{1} Grab a fast lens. You'll want to use a lens with at least an ƒ/2.8 aperture. The more light you can let in, the more you can decrease depth of field, and the more likely your image will exhibit smooth, creamy, out-of-focus areas.

{2} Select a large aperture to decrease depth of field, dramatically isolating focus on a narrow part of your subject. Everything surrounding this focal point will be blurred, thus creating bokeh. Apertures of ƒ/2.8, ƒ/1.8, and ƒ/1.4 usually create the nicest results.

{3} Increase the distance between your subject and the background. The farther away your background, the better your chances of getting some visible bokeh.

{4} Get nice and close to your subject. The shorter the focus distance to the foreground subject, the better background bokeh you'll get.

{5} Shoot!

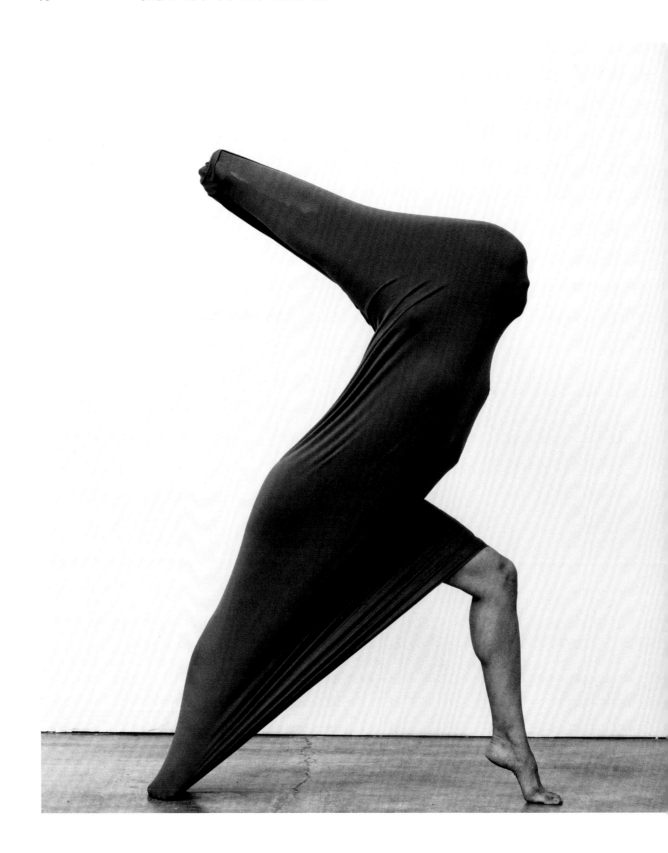

CAPTURE THE INTANGIBLE

Generally, you will go out into the world with the intention of shooting something tangible—a subject that you can see and touch like a person, object, or landscape—but the greater challenge is to go out with the intention of capturing something intangible—an idea, an emotion, a feeling, or a mood—and translating that powerfully though a single image.

I'm not talking about literal translations, either (such as a portrait of someone smiling to capture the emotion of "happiness"). Be creative and bold and non-literal. Play with light, colors, movement, filters, composition, and other tools and techniques to convey that idea, emotion, or mood in a way that's totally original, out-of-the-box, and even strange.

Try capturing:

- Happiness
- Sadness
- Love
- Kindness
- A secret
- Discovery
- Hope
- Danger
- Fear
- A dream
- A fleeting moment
- Something that scares you
- Urgency

GET ABSTRACT

One of my favorite challenges is to look for the surreal and the abstract in the everyday. Actively trying to find non-literal ways to present subjects allows you to see things that you wouldn't normally see, and stretches you as a photographer. Grab your camera and head into a city. (Cities tend to be filled with dynamic subjects to shoot in an abstract way, but your own neighborhood can work, too.) Before taking any photographs, study your surroundings carefully. Abstract images exist all around you. Keep an eye out for:

➤ COLOR

Look at things in terms of purely color. Do the subject's colors complement or contrast one another? Are they soft and faded or vibrant and intense? Is there a dominant color? Is there a way to create a compelling image purely using that subject's colors?

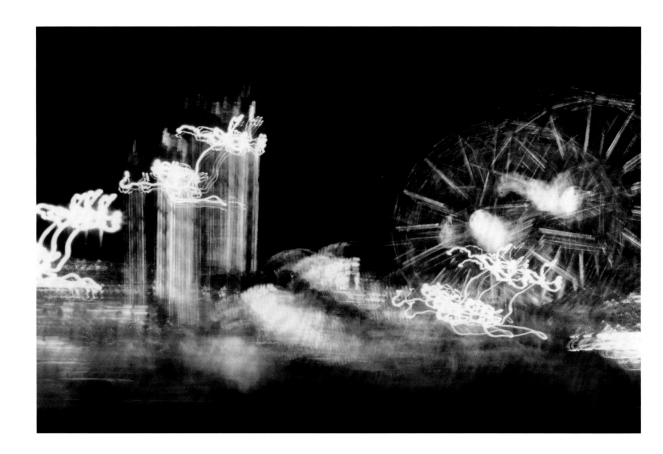

⇒ PATTERNS

There are natural patterns in pretty much everything if you look closely enough. Can you find any symmetries or parallels in your subject? Can you zoom in on any naturally occurring spirals or waves, curls or tessellations? Are there any irregularities that break the pattern?

⇒ TEXTURES

Look at a subject in terms of textures only. Is it smooth or rough? Soft or hard? Wet or dry? Shiny or dull? How can you play up the textures to create an interesting image?

⇒ FORMS

Zero in on a subject's natural forms and shapes, curves and lines. Do they convey a mood or feeling? Are they soft and sensual? Sharp and jagged? Do they create rhythm or drama? Do they impart a feeling of tranquility or excitement? Calm or chaos?

Often, a strong abstract image is an interplay of all of the above, but at the end of the day, no rules apply. Abstract photography doesn't need to have any specific meaning or purpose! Just go out there with the aim of capturing something interesting and striking and outside the box. The most important thing is that you're trying something new and having fun with it.

SHOOT SOMETHING 100 TIMES

One of the best creative exercises suggested to me by a mentor was to pick an object and shoot it 100 times. It might sound boring but, as with any kind of creative constraint, it stretches you creatively.

An ideal subject is one that is dynamic and can take on multiple forms. This isn't as difficult as it seems; a flower and even a simple egg are more multifaceted than you think and can take on many forms (as seen in the photographs opposite). Your subject is as interesting as you want it to be.

 Only one rule applies: The same composition cannot be shot twice. Besides that, you can get as crazy and creative as you want! Play with color, light, shadow, focus, and framing. Use different cameras (I recommend a pinhole camera or an instant film camera; see pages 51 and 118). Change up the perspective. Play with filters. Mess around with the subject itself. Turn it on its head; peel back its layers if it has any; see what happens when you break it. You'll be surprised at how many interesting shots you can get from one single subject, and how differently you'll look at any subject going forward.

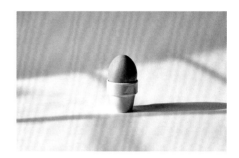

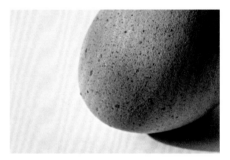

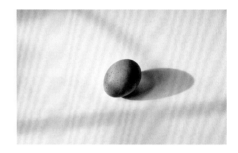

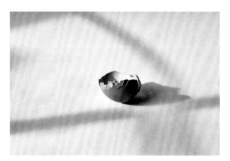

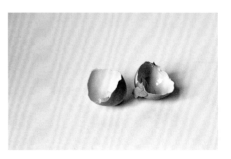

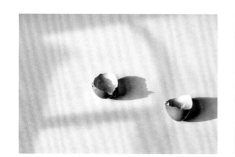

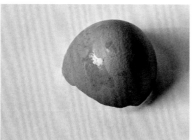

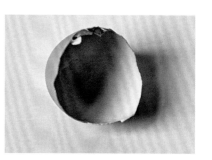

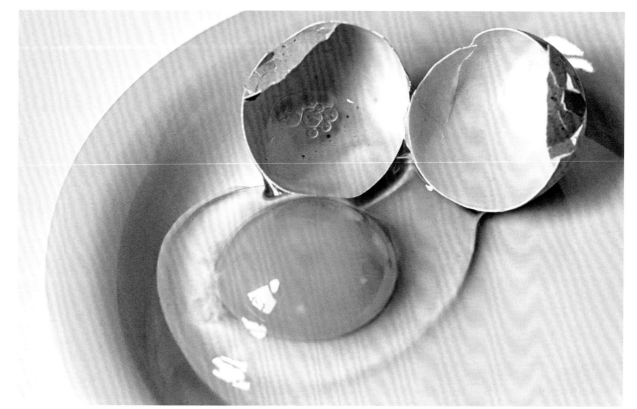

SHOOT A SHORT FILM

Stuck in a rut taking photographs? Try your hand at shooting video for a day. Most DSLR cameras these days are able to capture high-quality video and it's a waste not to use it! Many of the basic photography principles still apply (i.e., framing, exposure, and lighting) only you'll be shooting moving images instead of still ones.

I've found that putting on your filmmaker's cap trains you see subjects a little differently with more of an eye for detail and storytelling, which can translate into more complex and compelling photographs. Try the following exercise:

{1} Think of a subject. Find something that interests and inspires you. It could be a landscape, a person, a city, a cool neighborhood, a restaurant you love, a genre of dance—whatever.

{2} Create the narrative. Think of the story that you want to tell about the subject. Remember, you have more than just one shot this time so you don't have to capture the story in a single, still moment. You have the luxury of time and the freedom to capture movement, which makes it easier to tell a more complex story with a beginning, middle, and end. A two-minute film walking through a city might tell a powerful story about social disparity, for example. Even simple subjects like a single person can make for an interesting film ("a day in the life" is a classic narrative).

{3} Shoot! You might want to set the scene with a wide shot to give your film context and reveal key information about the location. Don't just shoot the obvious; as with still photography, always look for alternative angles and options. Shoot plenty of details. Try not to have any single clip last longer than 10 seconds, either. For the purpose of this exercise, you'll want to shoot plenty of interesting little clips that you can assemble together later into a short film.

{4} Edit your footage. Unless you plan to work with video regularly, you don't need professional video-editing software. Apple iMovie comes free with every new Mac and does the trick beautifully. Avidemux is also a great video editor that is free and user-friendly. That said, if you already use Adobe Photoshop or Lightroom, Premiere is a more robust software you'll take to easily (there's even a free trial period). During the editing process, make sure you're always keeping the narrative in mind; having a clear beginning, middle, and end is crucial. Otherwise it's just a collection of random shots. Keep it visually interesting by alternating between wide shots, medium shots, and detail shots, and even different angles. It doesn't have to be perfect; the key here is that it looks good to you.

{5} Watch, enjoy, and share!

SHOOT A SERIES

Many photographers tend to view a photo series as a long-term project, but it doesn't necessarily have to be. While some photo series can take months or years to create, others can take a week or even a day. A photo series is essentially just a group of photos with a common theme running through them that ties each photo together. Generally, it's a collection of the same or similar subjects or objects rather than simply a range of photos that fit within a wider theme.

When it comes to picking a subject, there are no rules! My favorite photo series range from Alexander Yakovlev's powerful dancer portraits to Seth Casteel's "Underwater Dogs" (which is exactly what it sounds like: photographs of dogs taken underwater that were later turned into a book). Another series I like was shot by photographer Thomas Hawk, who paid a homeless person $2 to pose for a photo whenever he was asked for money. It was an interesting concept: Instead of receiving a handout, the person earned the money by working for a few minutes while Hawk shot. Hawk, on the other hand, got a great photo series of interesting humans, many of whom had intriguing stories of loss and survival.

Here are some ideas to get you started. Use these as broader jumping-off points rather than final subject suggestions:

– Animals
– Couples (look up Murad Osmann's "Follow Me To" series)
– Bodies and the human form
– Weird portraits (look up Tadas Černiauskas' "Blow Job" series, which documented people's facial expressions as a high-powered jet of air from an industrial leaf blower was blown into their faces)
– Self-portraits
– Street portraits
– Movement
– Suburbia
– Occupations
– Stereotypes
– Reflections

– Nature
– Color (shoot a seven-day "rainbow" project, focusing on shooting things of a different color of the rainbow each day)
– Food
– Fashion
– Fantasy scenes
– Street style
– Cool signs
– "Ugly" things (your challenge is to make them look beautiful!)
– Heirlooms
– Social issues

REPLICATE YOUR FAVORITE IMAGE

Look at your inspiration board (see page 11) and pick out your favorite image taken by another photographer, preferably one of the greats (see "Study the Masters" on page 20). Now go out and try to replicate it as best you can, from the composition down to the subject, the shadows, the light, and every detail.

Let me be clear: I am not encouraging you to be unoriginal, or to pass off another photographer's work or creative vision as your own! This is merely an exercise that will allow you to see what another photographer has seen, and to slip into their creative mindset and better understand their creative decisions. It's less about the copying of the actual image itself and more about stepping into another photographer's shoes for a moment. (And sure, if a little of their genius rubs off on you in the process, that doesn't hurt either.)

If it's too difficult to replicate your favorite image, take a photograph that's directly inspired by that single image. Try to keep the essence of that photograph the same, but feel free to put your own unique spin on it. One of my favorite images of all time is the iconic photograph of a man jumping over a puddle taken by Henri Cartier-Bresson. Though it's not an exact replication and the setting and people are distinctly modern, the photo opposite was directly inspired by Cartier-Bresson's. Think of how you can do the same with your favorite image.

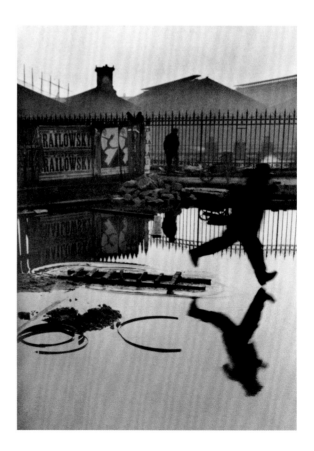

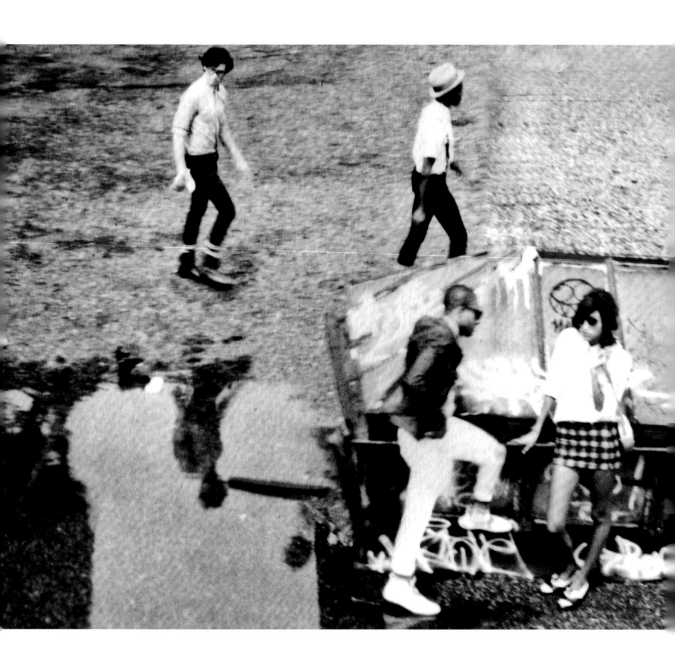

MAKE IT MEANINGFUL

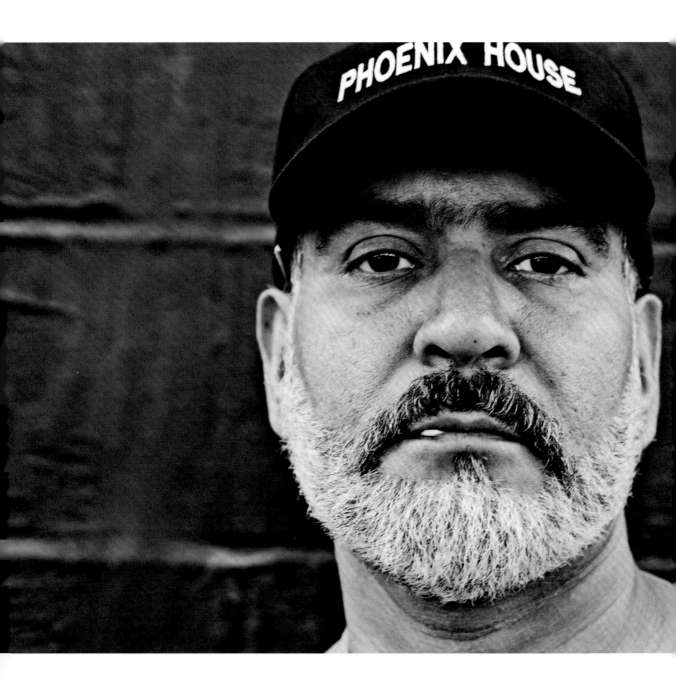

When you're stuck in a rut, it's easy to forget how powerful photography is as an art form. One single photo can be so impactful to a person, a group of people, and even society at large. No matter what your chosen genre, finding a way to use your skills in a way that's meaningful—not just to yourself, but to other people—can renew your love for photography and remind you of its immense power.

Even if your goal isn't to change the world with your photographs, there are plenty of ways to make your art more meaningful. For this exercise, I encourage you to find a path that inspires and works best for you.

Here are some ideas:

➤ FIND A SOCIAL ISSUE THAT IS IMPORTANT TO YOU

Do a photo project or series that highlights that issue. Examples include protecting the environment and climate change, women's rights, immigrants' rights, the Black Lives Matter movement, the elderly, and homelessness (read about Thomas Hawk's homeless portrait series in "Shoot a Series" on page 104). You can submit it to a publication or gallery or simply share it on social media afterward.

➤ VOLUNTEER YOUR TIME TO A NON-PROFIT THAT WORKS DIRECTLY WITH PHOTOGRAPHERS.

Now I Lay Me Down to Sleep (www.nowilaymedowntosleep.org) is a program dedicated to connecting professional photographers with medical professionals and families who have suffered the death of their newborn child. You can volunteer to be an on-call photographer who will have the privilege of capturing a moment between a parent and their child during that challenging time. Similarly, Help-Portrait (www.help-portrait.com) is a non-profit that finds people in need and connects them with photographers who will take their portrait, often for the very first time.

➤ TAKE A PROFESSIONAL PHOTO FOR SOMEONE WHO HAS NEVER HAD ONE BEFORE.

Not everyone has the opportunity to have a professional photo taken. They don't know what it is like to see themselves in the best light or to be seen as "beautiful." You have the power to change the way someone sees themselves! It could be anyone from a family member to a neighbor or friend. You can even do a call out on social media or Craigslist. It'll mean a lot to them and you might even be surprised at how much it means to you.

TAKE PORTRAITS

Not just any portrait! There are endless ways to take someone's portrait beyond just the classic studio shot, headshot, or environmental shot.

Instead, play with the following ideas:

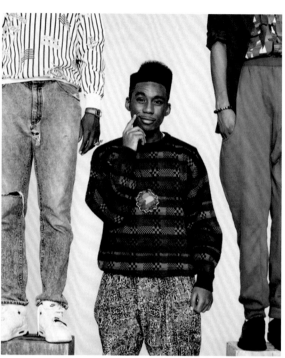

➤➤ FACELESS PORTRAITS

Capturing a person doesn't have to mean capturing their face. So much of a person's character can be revealed by their hands, their mouth, their gestures, and the way they move their body. Being a portrait photographer, I have taken hundreds, maybe even thousands of portraits, but two of my favorite portraits ever—of a farmer in Hawaii named Ka'ai— are of the back of his head (above) and his hands. There's something about his hair that is so cool and says so much about who he is; the same goes for his hands. You don't even need to see his face to get a sense of who he is.

➤➤ OFFBEAT PORTRAITS

As mentioned in a previous section, Lithuanian photographer Tadas Černiauskas once did a portrait series entitled "Blow Job" where he shot portraits of people as they were being blasted in the face by a high-powered jet of air from an industrial leaf blower. Russian photographer Alexander Khokhlov collaborated with a makeup artist to shoot "Weird Beauty," a series of portraits where subjects' faces were painted in highly unusual ways. There are endless fun ways to photograph people. The stranger and more surreal, the better!

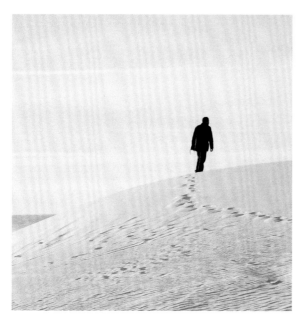

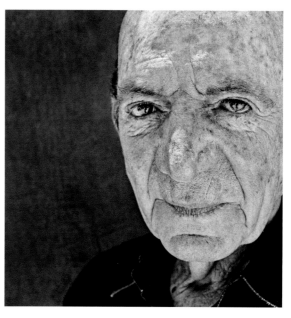

⟫→ SILHOUETTES

Silhouette portraits are a great way to convey drama, mystery, emotion, and mood. They're simple, striking, and are a great alternative to the standard environmental portrait. I recommend finding a beautiful location where you can shoot into the light at the beginning or end of the day.

⟫→ CLOSE-UP PORTRAITS

Instead of taking a photo of someone's face, why not get closer and focus on their eyes, or even just one eye? Highlight their long lashes, strong brows, beautiful laugh lines, or crow's feet. Focus in on a person's mouth, lips, smile, or a dimple. You could turn these images into a collage, or a series.

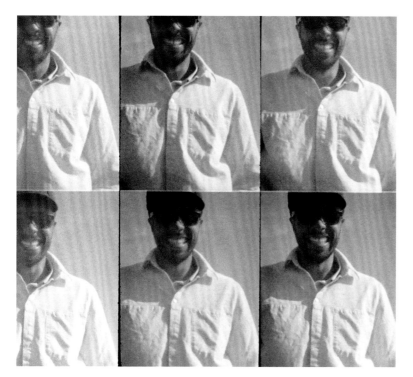

⟫→ SELF-PORTRAITS

I don't mean selfies! American photographer Cindy Sherman once famously photographed herself in costumes flanked with props and prosthetics portraying famous European artistic figures of the past. South Korean photographer Jun Ahn is renowned for taking vertigo-inducing self-portraits in which she is hanging off the world's highest buildings. Now I'm not suggesting you risk your life for a photo—that's an extreme example—but think outside the box and do something that pushes you outside of your comfort zone.

PUT PICTURES TO WORDS

Go to the library or your local bookstore, head to the poetry section, and pick a random book off the shelf.

Flip through it until you find a poem that piques your interest. Alternatively, you can browse through www.poets.org or www.poets.com or simply look for poems online. I recommend reading through the works of my favorite poets: Pablo Neruda, Omar Khayyam, Rumi, T.S. Eliot, Maya Angelou, and Amiri Baraka.

Take that poem, read it ten times, and then go out and shoot a photograph, or a series of photographs, that illustrates or is inspired by that poem. It does not need to be a literal representation; try to tap into the essence and feeling of a poem rather than trying to illustrate it, line-by-line. The picture I took opposite was directly inspired by a verse from a Walt Whitman poem, "Roaming in Thought": "Roaming in thought over the Universe, I saw the little that is Good steadily hastening towards immortality / and the vast all that is call'd Evil I saw hastening to merge itself and become lost and dead."

If poetry isn't your thing, passages from a book or lyrics to a song can be just as effective. The point of this exercise is to translate the written word into something visually meaningful.

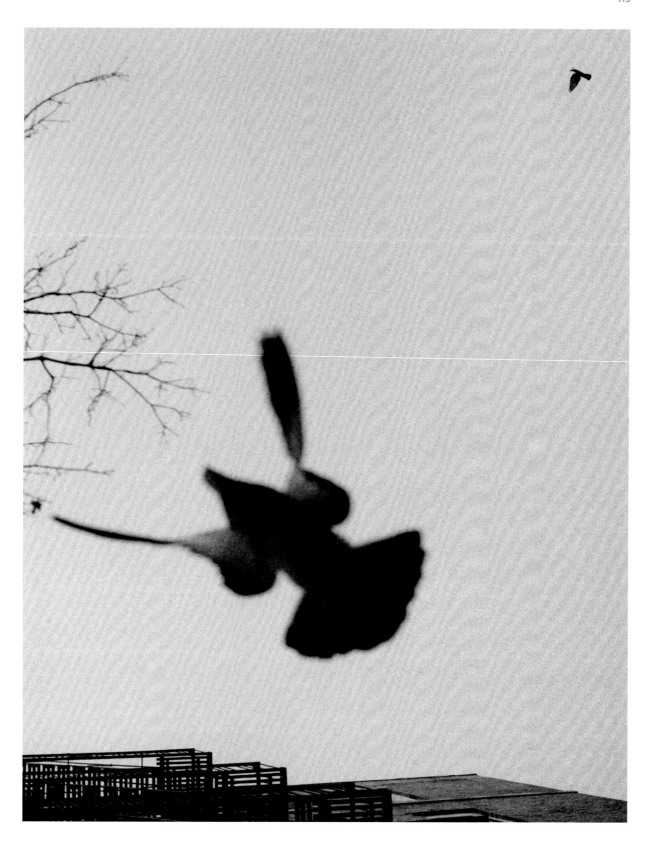

GO BACK TO BASICS

In this digital age of photography, it's easy to get caught up in all the impressive camera systems, fancy photo equipment, and perpetually advancing technology.

Cameras have never been equipped with more bells and whistles, memory cards have never been bigger or faster, and professional photo equipment has never been cheaper or more accessible, yet innovation and inspiration seems to be on the decline. Case in point: the demand for me to write this book.

Despite—or perhaps because of—all of the overwhelming options available to photographers today, I believe that less is more. Instead of buying a tricked-out new DSLR system, go the opposite route and get yourself a film camera. Shoot black and white. Build a pinhole camera. Process your own images. When it comes to photography, you don't always need more, or better. Sometimes, you just need to go back to where it all started.

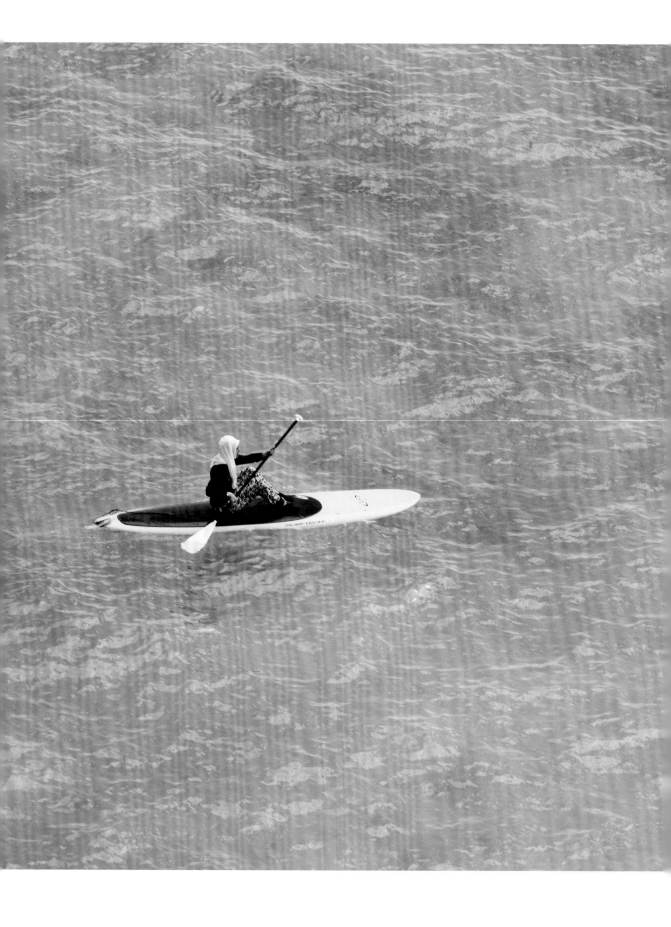

SHOOT FILM

Purchase a film camera at your local vintage shop, camera store, or online—or simply rent one—and shoot exclusively film for an entire week. Shooting film is something every photographer needs to try, especially in this digital age.

Besides the creativity-boosting constraints you get with shooting film (see "Shoot an Entire Roll of Film" on page 48), there are countless reasons why you should take a break from digital:

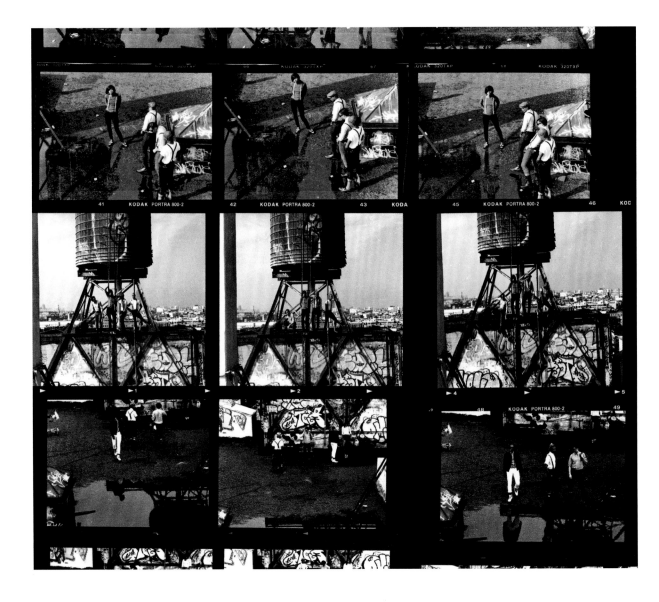

⤞ RESOLUTION

A recent study carried out by PetaPixel found that medium-format film could capture a jaw-dropping 400-million-pixel resolution photograph (50 to 80 million pixels after digital scanning). Larger formats were even found to capture 200-million-pixel resolution photographs—after being scanned! This matches and even exceeds the resolution of some of the world's best DSLR camera systems.

⤞ DYNAMIC RANGE

Digital photography is still dynamically challenged compared to film, though it has gotten infinitely better as technology has progressed. Film can still be manipulated to soak up more of a scene's tonal extremes and nuances, allowing you to recreate a scene that's much truer to what you saw with your own eyes. It's also more forgiving. Black-and-white images can be rescued up to six stops and under- or overexposed; color film allows you to bring out detail two stops above and below without sacrificing quality.

⤞ AESTHETICS

Film has aesthetically pleasing grain (the random appearance of small textures and imperfections within a photograph) that, in my opinion, gives a photograph character. In other words, film just **looks** better.

⤞ IT'S FUN!

Shooting film helps you better understand exposure, motion, and light. It teaches you patience and makes you a better photographer. Most of all, it is just really enjoyable.

FILM FORMAT REFRESHER

35mm: The most common photographic film format, the film is 35mm wide and each standard image is 24 x 36mm.

Medium format: Also called 120, 220, and 645, this film's measurements come in 6 x 4.5 cm, 6 x 6 cm, 6 x 7 cm, and 6 x 9 cm. Medium format gives far better technical quality than 35mm because of the larger negative size, and it's just as easy to use.

However, it is also more expensive and less portable. Mamiya (now PhaseOne), Hasselblad, and Pentax are notable medium-format brands.

Large format: Also known as 4 x 5 and 8 x 10 (but really can be used to describe any film size 4 x 5 inches and up), this film format is popular among serious professional photographers for its superior technical quality. All cameras look like old-time cameras with a flexible bellows. Graflex and Linhof are notable large-format brands.

USE A PINHOLE CAMERA

Taking it back to basics with a pinhole camera is one of my favorite ways to switch things up when I'm sick of taking pictures with my DSLR.

A pinhole camera is the simplest camera possible; it consists of a lightproof box, some sort of film, and a pinhole. Light from a scene passes through this pinhole and projects an inverted image onto the opposite side of the box, producing an image on the film. That's it. There's no lens, no aperture control, no viewfinder (yep, you read correctly). Your final image depends almost entirely on exposure and framing, and there are a lot of unknowns.

This is precisely why you should try it! Shooting with a pinhole camera is an awesome challenge. I hate to sound like a romantic, but you're creating an image made with a camera stripped down to the bare essence of what photography is—the basic physics and geometry of it, without all the mechanics.

After some practice and experimentation, you can get some really striking, surreal, and interesting images (characteristics of pinhole photography include wide angles, soft focus, vignetting, and infinite depth of field). You can change things up by experimenting with exposure times, motion, and by playing with the distance of objects or subjects to the camera. You can also get countless different effects by bending the film, putting it in diagonally, or by wadding up the negative.

Though you can make your own pinhole camera using any kind of box (or even a coffee can), I think it's worth investing in one that you can travel with and can use forever. I highly recommend Lensless pinhole cameras (get them at www.pinholecamera.com), which are handcrafted out of birch wood and mahogany and come in every format imaginable. They take terrific pictures and are so beautiful that you'll want to take it out with you every day.

SHOOT BLACK & WHITE

Shooting in black and white isn't just a technical limitation; it's an awesome creative choice and a great way to switch up your photography. It's something every photographer should try for the following reasons:

⟫→ IT HELPS EMPHASIZE MOOD AND EMOTION

Color can actually be a distraction at times and can hide a multitude of sins. Take a portrait, for example; the hues of a person's makeup or clothing (or even the background) can distract from really seeing the person. By eliminating color and paying more attention to lines, shadows, shapes, and textures, you're able to capture expressions and moods more purely and effectively. Try it.

⟫→ IT HELPS YOU TO SEE LIGHT DIFFERENTLY

When you take color out of the equation, you'll find that you're focusing more on the direction, quantity, and quality of light in a frame.

⟫→ IT GIVES YOU MORE CREATIVE FREEDOM

Sounds counterintuitive right? Think of it this way: When you're shooting in black and white, you're able to focus on other things besides making colors work together or pop, which can change the very structure of an image. Having clashing or jarring colors in the frame, for example, is no longer an issue so you are immediately able to be more daring with composition. In my opinion, forgetting about color frees up brain space so you can really work on elements like composition, light, negative space, and contrast. (High contrast is often discouraged in color photography but it can amp up the drama beautifully in a black-and-white image.)

⟫→ IT MAKES YOUR IMAGES FEEL TIMELESS

Black-and-white photography just looks good. It lends a classic, timeless aesthetic to images that I just don't think color photography intrinsically has.

Try photographing the following in black and white:

- A friend
- A flower
- A street scene
- A skyline
- A natural landscape
- A reflection
- A detail
- Yourself

LEARN COLOR THEORY

Unless you went to photography or art school, chances are you weren't taught about color theory. What exactly is color theory? Put simply, it's the technique of combining specific colors in a way that looks best.

Fundamental to color theory is the color wheel—a circular depiction of every color along a continuum, with each color transitioning into the colors on either side of it. Color theory states that colors directly opposite from one another on the wheel work well together visually, and, when used together, can help make an image feel balanced.

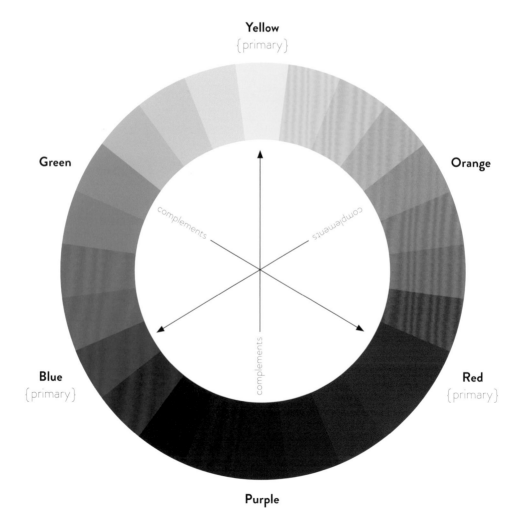

✳ **TIP: Go out and take five photographs that highlight complementary colors and five photographs that create a mood using analogous colors.**

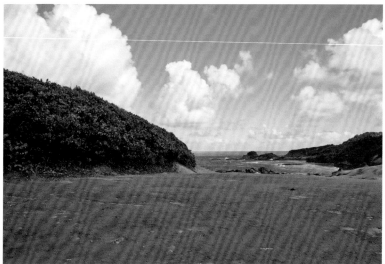

There's much more to color theory than just complementary colors, however. Another aspect is that of analogous colors. This is the idea that colors close to one another on the color wheel are naturally harmonious when seen together and create a certain feeling and mood. For example, using colors in the red-to-yellow section of the color wheel can create a warm and inviting mood in an image. Conversely, using colors in the green-to-blue section of the color wheel can create a calm, relaxed, and mellow mood.

You certainly don't need to go out and apply color theory to every single picture, but it is useful to know which colors complement one another, which colors contrast one another, and which colors can help create a certain mood in an image. Just like lighting or compositional tools, understanding colors and how they interact with one another can make for better images.

USE A DARKROOM

I know what you're thinking: Who uses an actual darkroom in the 21st century? It's slow, tedious, often frustrating (every tiny element can have a profound effect on the final image produced), and quite simply unnecessary.

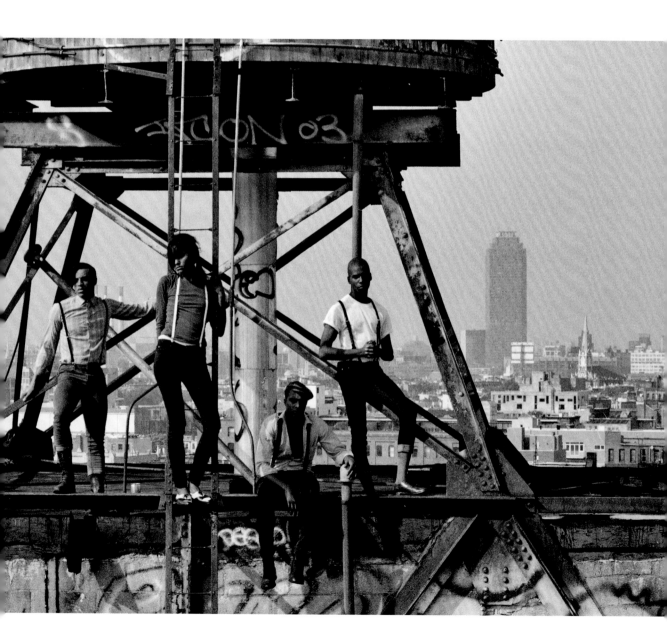

However, many professional photographers today—myself included—still do it out of love and respect for the art of photography. The process of developing images in a darkroom is magical and infinitely rewarding! And it's something that every photographer should try for those reasons alone.

Most major cities have darkrooms for hire by the hour. Otherwise, reach out to your local photo school, art school, or photo lab. Alternatively, you can build your own!

BUILD YOUR OWN DARKROOM

Find a very dark room or space: A bathroom or basement is ideal, but a 5 x 5-foot (1.5 x 1.5m) closet can be made to work in a pinch. Ideally, your space will have running water, electricity, and some kind of ventilation (i.e., a bathroom with a fan).

Make the room light tight: Use black curtains or blackout sheeting and tape the bottoms of doorways and the sides of windows with gaffer tape to prevent outside light from leaking in.

Plan distinct "wet" and "dry" areas: Your "wet" area is for the storing and mixing of chemicals, tank and tray processing, and the washing of equipment. The "dry" area, preferably near an electrical outlet, is for your enlarger, storage of your photographic paper, and storage of equipment you want to keep ready for use, like developing tanks.

Invest in a good enlarger. An enlarger is a darkroom tool that projects images from negatives onto enlarging paper. A simple, sturdy one with a good lens will do. Reputable brands include LPL, Durst, Beseler, and Meopta. You can find some great, cost-effective enlargers on eBay, in vintage stores, and camera shops.

Purchase a darkroom kit. If it's your first time using a darkroom, I strongly recommend purchasing an existing darkroom kit or starter pack. These are easy to find online at eBay, B&H Photo, or at any reputable camera shop. This will include everything from trays to tongs and a photographic safe light (which enables you to see in the dark without ruining your prints). Some kits even come with all the chemicals you need. Most importantly, all darkroom kits are equipped with a detailed instruction manual on how to process your own images, step by step.

Example wet/dry area layouts:

INDEX

This book would not have been possible without the continual support, guidance, and hard work of the team at Ilex Press, specifically Adam Juniper, Frank Gallaugher, Francesca Leung, Meskerem Berhane and all the many editors and designers who worked to make this book something that we can all be proud of. Special thanks goes out to Peter Clark and Heather Thomas at Attic Studios in New York for providing me with an incredible space to shoot many of the images within the book.

Thanks also to models Natasha Diamond-Walker, Rhiannon Lattimer, Ivy Hjornevik, and Henry Kingsland for helping bring many of my creative exercises to life; to stylist Darryl Glover for his enthusiasm and creative vision; to Savannah Camastro for her invaluable assistance on set; and to Fujifilm Instax and Lensless cameras for partnering with me on this project.

Finally, I'd like to thank my amazing wife, Krisanne, for her love, support, and encouragement during this entire process.